EAST BE ore

FAERNA, Jose Maria (ed.)

16 200/

G Braque

Great Modern Masters

Braque

General Editor: José María Faerna

Translated from the Spanish by Alberto Curotto

CAMEO/ABRAMS

HARRY N. ABRAMS, INC., PUBLISHERS

Braque and the Origins of Cubism

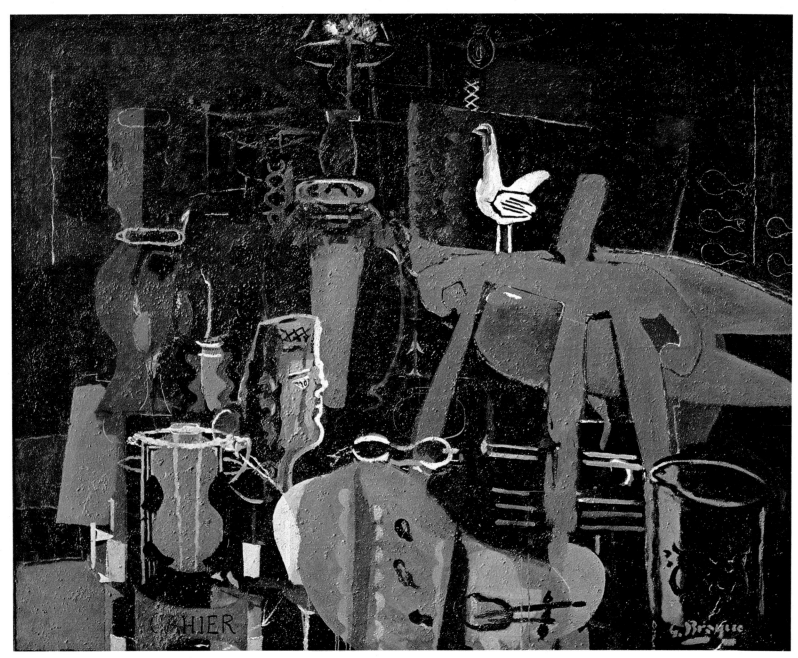

Studio VI, *1950–51. Oil on canvas, 51⅛ × 64" (130 × 162.5 cm). Fondation Maeght, Saint-Paul-de-Vence*

The painter Georges Braque cannot be examined separately from either the Cubist revolution or from his relationship with brilliant fellow artist Pablo Picasso. Braque and Picasso, founders of the most influential aesthetic movement of the twentieth century, actively pursued the study of the connection between form and the space it generated. This new pictorial space was already implied in Picasso's famous 1907 painting *Les Demoiselles d'Avignon*. That same year, when Braque first saw this work, the painting's formal rawness and its fiercely expressive content exploded his sense of clarity and order. In that period, the French painter still felt a

certain affinity with Fauvism, to whose formulation of drawing and color he subscribed.

The Spell of Cézanne

Nonetheless, Braque's austerity and calm intelligence could certainly not sustain the degree of fervor engendered by Fauvism. He soon realized that, for him, other aspects of nature were of greater importance, and he identified in Paul Cézanne the foundation of his own aesthetic interests. Curiously enough, Picasso's own evolution as a painter had taken a some-what similar turn, as evidenced by the landscapes of Horta de Ebro that he painted in 1909. Thus, several months before the two artists began their intimate friendship and artistic collaboration, both had independently absorbed the ambiguity of Cézanne's color planes, which they saw as per-forming two different functions: an illusionistic one, as a chromatic equiv-alent to the depth and position of the natural object—and a material one, as a field of color on the surface of the painting. However, unlike the works of the older master, the paintings of both Braque and Picasso exhib-it color planes that receive light from several different points at once, thereby creating pictorial spaces that could not exist in the physical realm.

A Parallel Evolution

It was around this time that the term *Cubism* was born. In November of 1908, the young, Paris-based German art dealer Daniel Henry Kahnweiler organized an exhibition of works painted by Braque during the previous year. In his review, the critic Louis Vauxcelles—who, three years earlier, had coined the label *Fauve* ("wild beast")—described Braque's images as being reduced to "little cubes." In March of the following year, when two of the painter's works were shown at the Salon des Indépendants, the same critic spoke of the artist's *bizarreries cubiques* ("cubic eccentrici-ties"). During 1908–1909, Braque and Picasso's stylistic experiments fol-lowed a parallel course, but in late 1909, and to a considerably greater extent in the period 1910–11, both converged onto a remarkably similar conception and execution. It has by now become cliché to speak of the difficulty in differentiating the authorship of the works executed in this period, and of the fact that the artists themselves sometimes mistook the other's work for his own. Such coincidence of execution reached its peak in two works from 1911: Braque's *The Portuguese* and Picasso's *The Accordionist*. Both paintings, like others from the same period, are exe-cuted in a monochromatic palette of grays and browns, with very light touches of ocher, black, and green. This reduced range of colors was one of the Analytical Cubist methods exercised in the quest for the reality of the object, or its tangible existence in space rather than its appearance. It

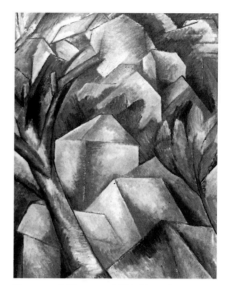

Houses at L'Estaque, *1908. These "little cubes," embodied in the houses of the title, are at the very origin of the name Cubism.*

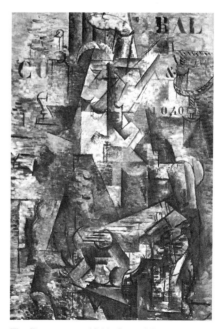

The Portuguese, *1911. One of the most typical works by Braque, dating from the years when Analytical Cubism was at its height.*

was also a natural reaction to both the self-expressive brilliance of the Fauvists and the Impressionists' approach to dissolving matter into the subtle glow of appearances. The critical distinction between early, Analytical Cubism, from 1908 until 1911, and Synthetic Cubism thereafter is based on the differing approaches to the representation of objects practiced in each phase. Objects from the Analytical stage seem to dissipate into the surrounding projected space, while during the Synthetic phase, they materialize visually through a system of illuminated, changeable, and interlocked planes, and through greater use of color. The apparent estrangement from reality in Analytical Cubism led both painters to rethink the relationship between the work of art and the physical world of objects, bringing the former closer to the latter. Braque was the first to introduce commercial advertisements into his painting as a way to contrast the simple presence of ordinary objects with the conceptualized aspects of the main form. The artist's intention, in his own words, was "to get as close to reality as possible."

Papiers collés

Later, in 1912, Braque put to use some techniques he learned as a house-painter's apprentice by blending his pigments with such seemingly rudimentary materials as sand, sawdust, and metal filings; he also employed a method of simulating the grain of wood by dragging a decorator's comb over the wet painted surface. While it was Picasso who subsequently borrowed from his friend these methods of imitating reality, Braque in his turn followed the example of the Spanish painter when, in May 1912, Picasso invented the collage. In Braque's earliest *papiers collés* (a type of collage composition consisting only of pasted paper), the level forms of the objects are intermixed with pieces of paper, a technique enabling the conceptual reality created by Cubism to attain a new intellectual dimension, since the painted forms were, artistically speaking, more "real" than the imitated ones.

The Harmony of the Object

Braque once said that he no longer had any faith to speak of, which can be inferred from the absence of external themes in his work. Even the classical motifs, which he began painting in the 1920s, are used as mere pretexts of pictorial invention, thoroughly devoid of any iconological commentary. "For me," Braque explained, "objects exist only as far as their mutual harmonious relationships, as well as those between the objects and myself, are concerned. Whenever this harmony is achieved, a sort of intellectual nonexistence is attained that makes everything possible and just." In his subsequent thematic choices, Braque painted mainly still-life objects or a single figure sitting or standing, thereby remaining loyal to the earliest Cubist iconography and new pictorial space he and Picasso had explored together. Picasso once declared that, when he and Braque invented Cubism, they had not set out to do exactly that, but "merely to express what was within [them]selves." In developing a particularly sensitive individual expression, Braque's work thus unfolded the formal and technical elements of the Cubist vision itself. Braque's art, not unlike his own life, was less evocative than Picasso's, his brushwork more discreet, and his formal metamorphoses less spectacular. And yet, to a greater extent than Picasso or Fernand Léger, it was Braque who strengthened and expanded the Cubist notion of pictorial space.

Georges Braque/1882–1963

Born in Argenteuil, near Paris, Braque had the opportunity to familiarize himself with painter's brushes at an early age, his father being the manager of a decorative painting business. The artist himself was employed early on as a decorator, and he would later integrate into his own paintings many of the techniques he had learned during that formative stage. His personal interest in tactility—a legacy of the family trade—would lead him in pursuit of various textured surfaces that enhanced the tangible quality of both the painting and the object represented. In 1899, Braque moved from Le Havre, where he had spent most of his adolescence, to Paris. The artist first exhibited his work—a series of canvases in the Fauvist style—at the Salon des Indépendants in 1906.

Fall 1907

The year 1907 was a time of pivotal significance in Braque's life. In the fall of that year, he was introduced to Picasso and, in the latter's studio, he saw the recently completed *Les Demoiselles d'Avignon*. The friendship between Picasso and Braque was a typical example of two opposites attracting one another. In the words of a common friend of the artists, "Braque was limpid, measured, bourgeois; Picasso was somber, excessive, revolutionary." Cubism, the new artistic idiom they created together and explored in their respective works, undoubtedly fulfilled the artistic visions of both. From 1908 until 1914, when Braque's tour of duty in World War I separated the two, their friendship remained a mutually enriching experience. "We would get together every single day," said Braque, "to discuss and assay the ideas that we were forming, as well as to compare our respective works." While Picasso eagerly gave in to the seductive power of the many new morphological, configurational, and iconographic possibilities afforded by their discoveries, the more explicit evolutionary outline of Cubism can perhaps be traced more readily in the works by Braque.

Cubism

As a matter of fact, the majority of the innovations that Cubism introduced into the modern artistic practice—such as the inclusion of printed letters in the painting, the use of pigments blended with sand, the simulation of woodgrain and marble, and Cubist paper sculpture—were originally conceived by Braque, even though it was Picasso who pushed them to their limits. Conversely, it was Braque who borrowed the collage technique from Picasso's 1912 work *Still Life with Chair Caning*, an oval painting with a piece of oilcloth pasted in its lower part. Around the same time, Braque produced *Fruit Dish and Glass*, in which three pieces of paper, imitating wood, are integrated into a charcoal drawing. By contrasting the artistic execution of Braque and Picasso in this collage method, one can also readily compare their different artistic personalities. Thanks to his feeling for an underlying trenchant compositional harmony, Braque did succeed in transforming his repertoire of commonplace objects into exceptionally elegant designs. As for Picasso, who was a careful observer of the physical world, he could easily forgo all decorative considerations

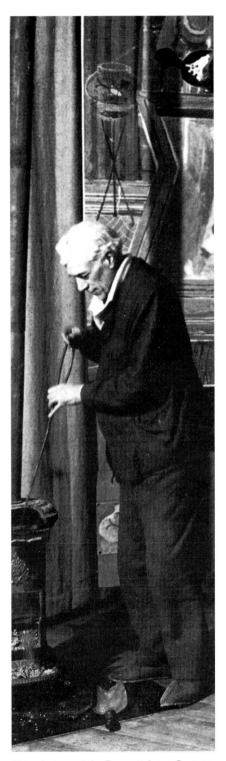

This photograph by Brassaï shows Georges Braque in his Paris studio surrounded by a number of his works. The mood of this image is reminiscent of the Atelier (Studio) *canvas series that the artist painted between 1948 and 1955.*

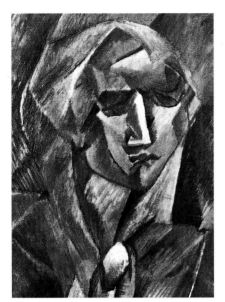

Head of a Woman, *1909. Even though Braque, throughout his career, was never interested in portraiture, he did in some instances depict the human figure in renderings reminiscent of still lifes.*

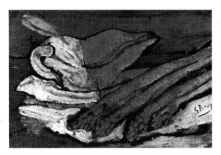

Sauceboat and Asparagus, *1924. This appears to be a reinterpretation of a well-known still life painted by Édouard Manet in 1880.*

Sitting Woman, *1934. This etching constitutes a loose interpretation of Cubism's formal repertoire.*

to convey the immediate experience of forms as derived from his close observation of them. Several years later, Picasso would describe Braque's departure in 1914 to join the armed forces in World War I as a final farewell between the two friends. In a way, that good-bye signaled a conclusion of sorts, since thereafter the two artists were never close again. After the war, in a letter to Kahnweiler dated 1919, Braque speaks of what appears to be a manner of desertion on the part of his old friend: "Picasso has created a new genre known as Ingresque," he said, referring to the Spaniard's representations of the dance world and to his naturalistic portraits. Despite this breach, over the course of the following decades their respective works continued to teem with reciprocal affinities and counterpoints.

A New Style

In 1915, as a result of a very serious head wound, Braque was forced into a long period of convalescence that prevented him from painting until 1917. In 1919, his new dealer, Léonce Rosenberg, organized a solo show of his work. The series of still lifes that the painter produced in those years and in the decade following, characterized by a limited palette of green, ocher, and white over a layer of black, brought him even greater international renown. During the 1930s, Braque's style underwent a significant change. The restrained colors of his former works gave way to more subtle and delicate hues—pink, pale green, yellow, and lavender—while the objects represented acquired a distant and static appearance, as a result of the aesthetic confinement in which they are held. In those years, Braque lived completely isolated from the world outside his studio, and the motifs that he employed in his work were not inspired by nature as much as by the drawings and sketches he executed after preexisting paintings.

Eternal Classicism

The period 1931–32 saw the emergence of the first of the Greek heroes and deities that Braque would depict in a number of drawings, as well as in the series of sixteen prints that he created for the French art dealer and publisher Ambroise Vollard's edition of Hesiod's *Theogony*, quite possibly the most important example of Braque's illustrated books. More themes drawn from Greek antiquity were to appear in Braque's 1945 production of lithographs for *Helios and Phaëthon*, as well as in his flat sculptures and, on a larger scale, in *Ajax*, a painting on paper whose execution occupied him between 1949 and 1954. All of these works have been widely regarded as mere formal exercises and as being essentially stripped of all symbolic significance—a sort of late contribution to the far-reaching return to classical themes and subject matter that took place in the aftermath of World War I. Between 1948 and 1955, Braque completed a series of eight canvases, each one entitled *Atelier (Studio)*, which is considered the very culmination of his painterly career. The theme of these paintings is not so much the artist's studio as it is the space surrounding the things it contained. The objects are placed in a temporal stream, in ever-changing positions that make it impossible to view any one in its entirety at any given moment. The spectral presence of a bird in the upper section of these paintings does not refer to the external natural world; rather it draws the viewer to the core of Braque's own painterly universe, where, as the artist once wrote in his notebook, "the present is perfect."

Plates

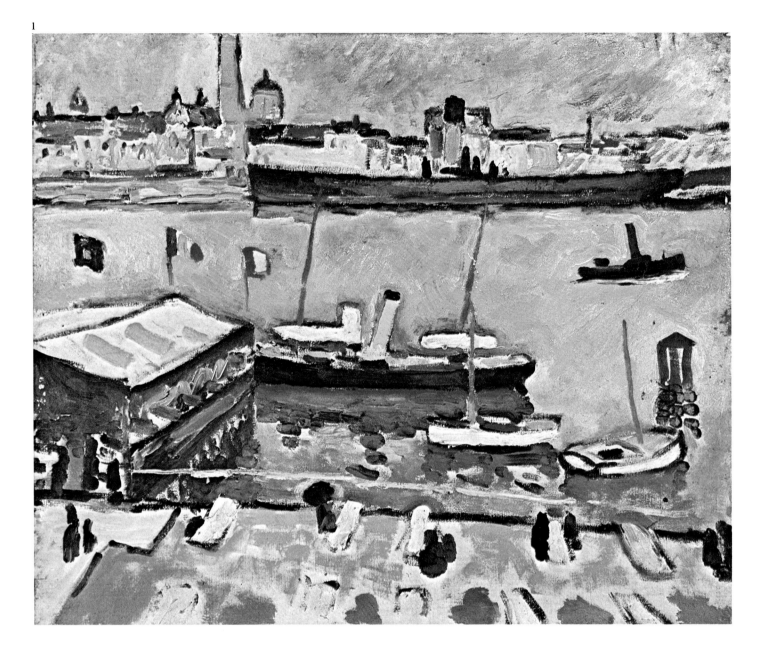

Color Landscapes

Braque arrived in Paris in 1899 in the company of his friends and fellow painters Othon Friesz and Raoul Dufy. However, it was not until 1902 that he decided to abandon his practice as a decorator to devote himself entirely to fine arts. The only surviving works from this period (1902–05) are some Pointillist seascapes which, despite not finding them entirely satisfactory, he exhibited at the Salon des Indépendants of 1906. It was rather the Fauvist works painted in Amberes during the summer months of 1906 that Braque considered the real beginning of his career as an artist. According to a number of the painter's own statements, his "conversion" to Fauvism was brought about by his encounter with the works of Henri Matisse and André Derain, which he had seen firsthand at the Salon d'Automne of 1905. "Fauvist painting," he further confessed, "succeeded in leaving its mark on me by virtue of its innovative character, which I thoroughly enjoyed . . . it was a painterly style rife with enthusiasm, which well suited my own age; I was then twenty-three . . . inasmuch as I frowned upon Romanticism, this physical type of painting gave me much pleasure."

1 The Harbor at Antwerp, *1906. This is one of the most typical paintings from Braque's Fauvist period. Colors are extremely well defined, and the brushwork of the water and the sky is very vigorous. On the whole, it is a schematic picture that appears to have been conceived and painted in the artist's studio rather than outdoors before the depicted motif.*

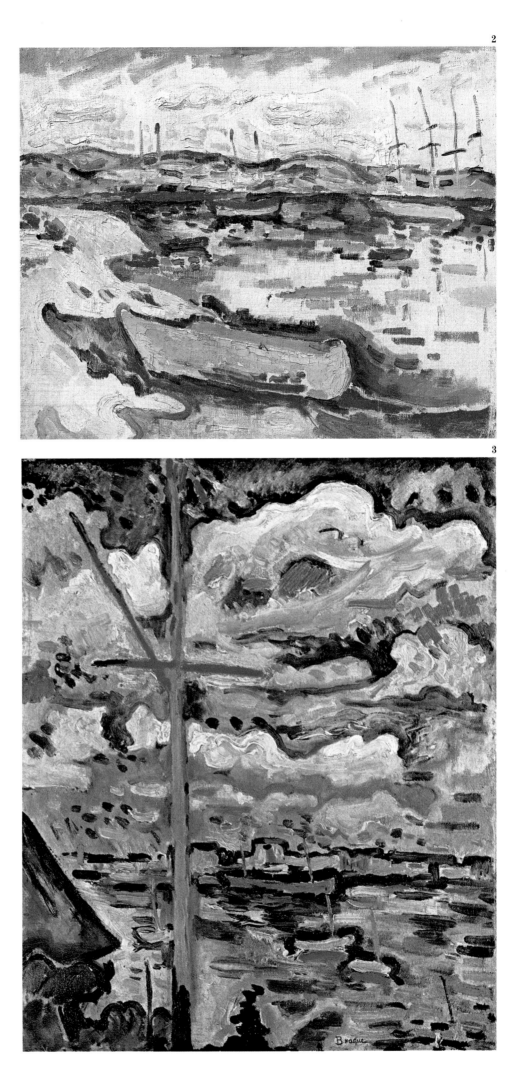

2, 3 The Port of L'Estaque, *1906;*
The Port of Amberes: The Mast, *1906.*
Both paintings are characterized by
the use of intense and absolute tones,
without concern for the reproduction
of local color, as well as by a type of
brushwork reminiscent of Vincent van
Gogh. The final result emanates an
unusually intense expressive vigor.

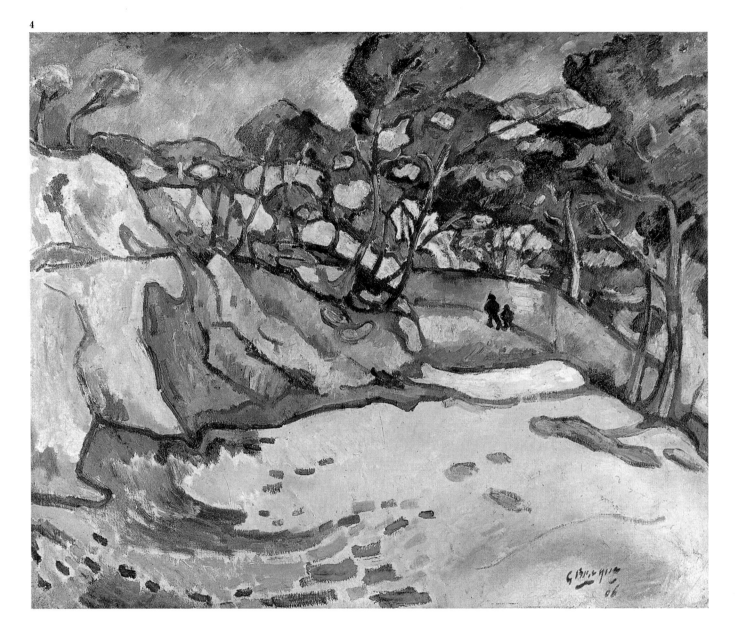

4 Landscape at L'Estaque, *1906. In the fall of this*
year, Braque traveled to L'Estaque, a small port town
in the vicinity of Marseille. The canvases painted in
the course of his sojourn there are considerably
richer and more complex than those he produced in
Amberes, clearly indicating that, in addition to the
Fauvists, Braque had also studied their Post-
Impressionist precursors.

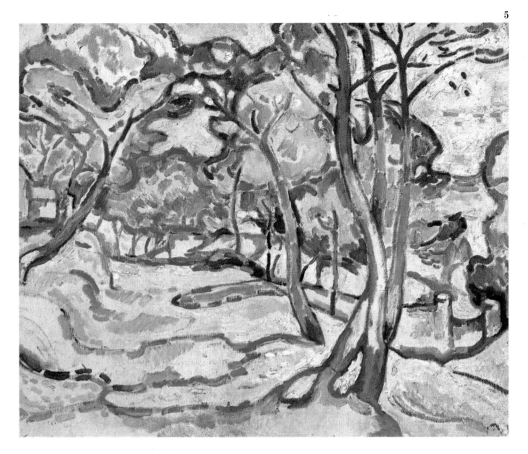

5, 6 Landscape at L'Estaque, *1906; Olive Tree near*
L'Estaque, 1906–07. The dense forms with blue
shadows, as well as the rigorously outlined rocks and
trees, are strongly evocative of Paul Gauguin, a
retrospective of whose work was held that same year
at the Salon d'Automne. Among the distinctive
features of Braque's paintings from this period are
the elongated brushstrokes that stretch into ribbons
of color.

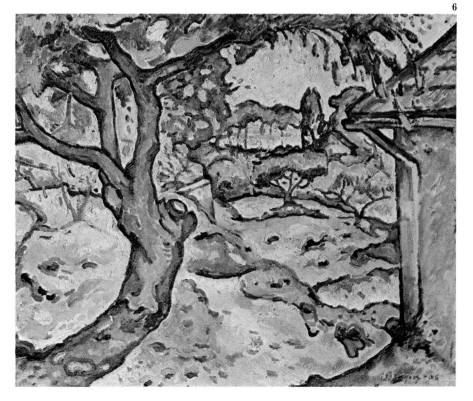

In Cézanne's Footsteps

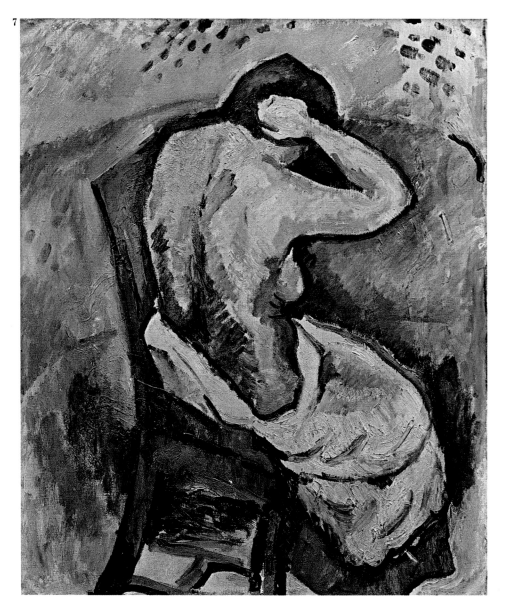

In the fall of 1907, the commemorative exhibition of Paul Cézanne's oil paintings held at the Salon d'Automne, and the retrospective of his watercolors at the Galerie Bernheim-Jeune, together with the publication, that same year, of his correspondence with the painter Émile Bernard, proved a salutary lesson for Braque, who was thereby induced to reconsider the Fauvist principles with which he had been working. In the landscapes that he painted in the summer months of 1908 and 1909 at L'Estaque and in La Roche-Guyon—two of Cézanne's own favorite resorts—the geometric simplification of the architectural structures and of the trees is clearly based on the example of Cézanne. Braque's encounter with Picasso in 1907 and the discovery of his *Les Demoiselles d'Avignon* marked another pivotal moment in the artist's life as well as in his evolution as a painter. Picasso's painting at once disconcerted and inspired him. It bolstered his conviction that it was necessary to strengthen the constructive elements in his own works while, at the same time, forgoing the expressive excesses of Fauvism. Braque's paintings seem to sanction something that Gleizes and Metzinger wrote in *Du Cubisme* (1912): "Those who understand Cézanne portend Cubism." In point of fact, after Kahnweiler organized the first solo show of Braque's paintings in 1908, it was one of the reviews of that exhibition that promulgated the term *Cubism*.

7 Seated Nude as Seen from Behind, *c. 1907. This work evokes unequivocally the extent to which Braque's work was then already indebted to Cézanne. While his use of colors is still within the Fauvist range, the fracturing of the pictorial space and the sculpturesque quality of the forms are a prelude to some typically Cubist discoveries. The lack of definition in the background serves to emphasize the pronounced mass of the woman's body.*

8 Large Nude, *1907–08. Braque's formal investigations followed a parallel course to those by Picasso, who, in 1907, was working on* Les Demoiselles d'Avignon. *The distorted portrayal of this nude results from the flattening and twisting of the figure, which is viewed from several different vantage points at once.*

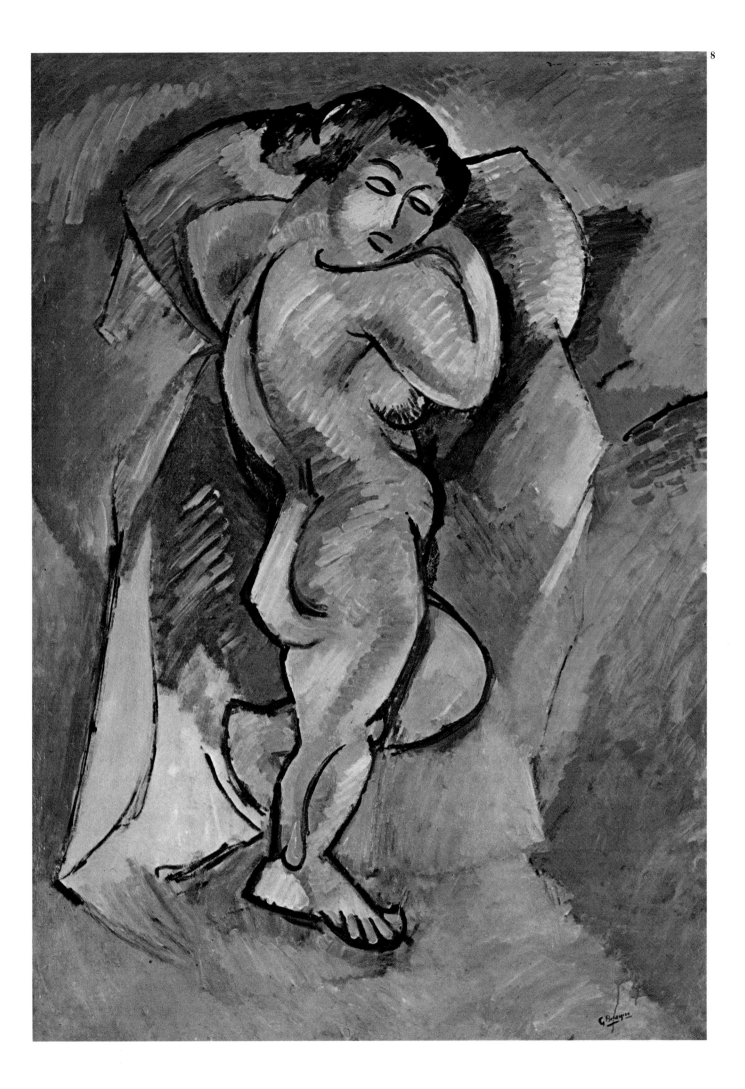

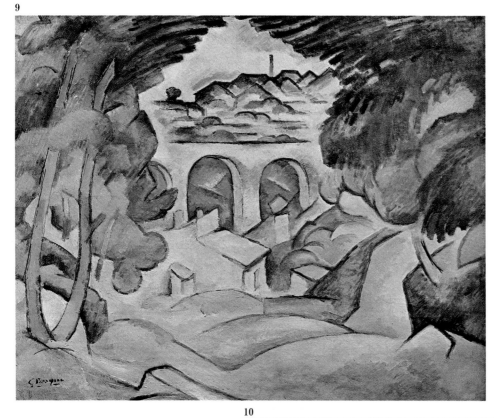

10

9 Viaduct at L'Estaque, *1907. In his book on Braque's oeuvre, Pierre Reverdy once offered the observation that "nature does not exist." The forms and colors in this painting do not match reality, and the nervous quality of the brushwork gives rise to a certain restlessness, while the solid and geometric shapes of the houses create an extremely dense pictorial space.*

10 L'Estaque Landscape, *1908. The consistency of a single bluish green hue throughout the painting emphasizes the unreal quality of this image, which lacks any precise light source, but whose objects appear to radiate their own inner light. The painting has no visible horizon, possessing its own autonomous inner life.*

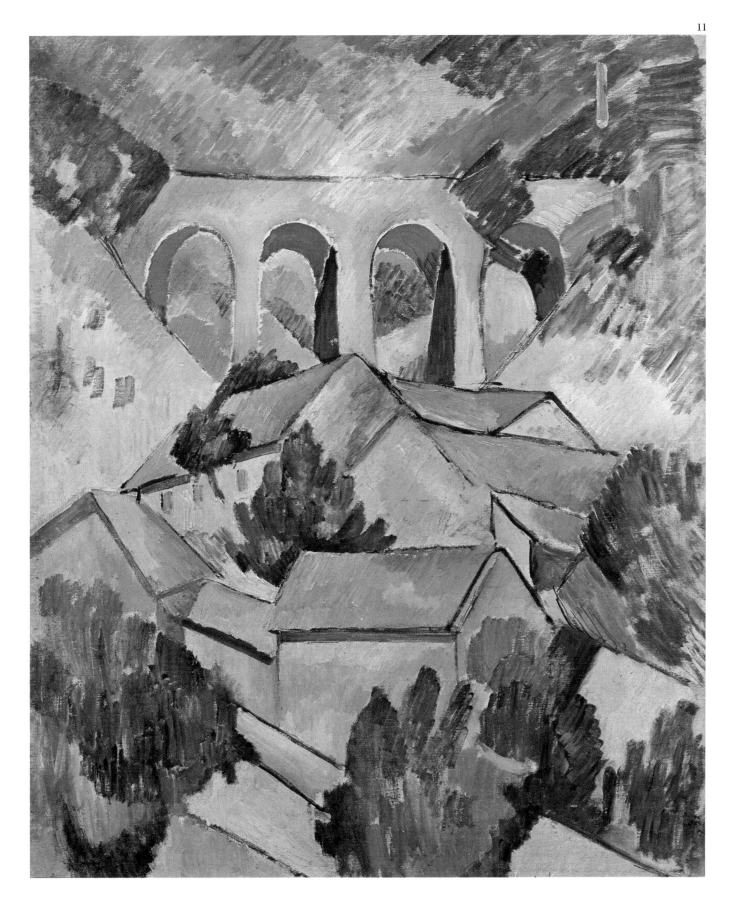

11 Viaduct at L'Estaque, *1908. The limited number of colors and
the simple opposition of curved and angular forms are the most
significant features of the works that Braque painted in this
period. The process of distortion, combined with the contradictory
casting of shadows, renders the question of perspective irrelevant.*

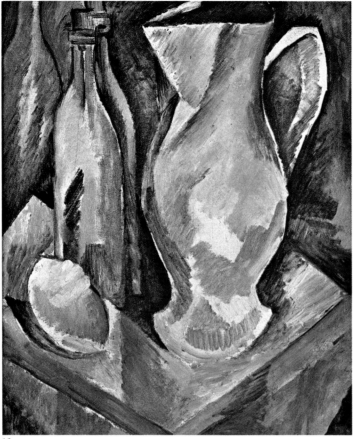

12

The Birth of Cubism

These were the years when the collaboration between Braque and Picasso was the closest and most productive. While it may not seem necessary to adopt a categorical distinction between early Cubist painting—Analytical Cubism—before 1911 and Synthetic Cubism, its subsequent incarnation, works from these two phases clearly show different motivations at play. After devising a way to register their experience of the visual and tactile effects produced by objects in space, Braque and Picasso began creating new forms and types of compositions in which naturalistic references were "synthesized" in planes, colors, and shapes that bore no relation to the world of appearances. Cubism succeeded in visualizing, within the framework of twentieth-century art, Leonardo da Vinci's definition of painting as a *cosa mentale* (a thing of the mind). Such has unquestionably been Cubism's most significant contribution to the generations of artists that followed, the work of Marcel Duchamp being no less indebted to it than that of Piet Mondrian.

13

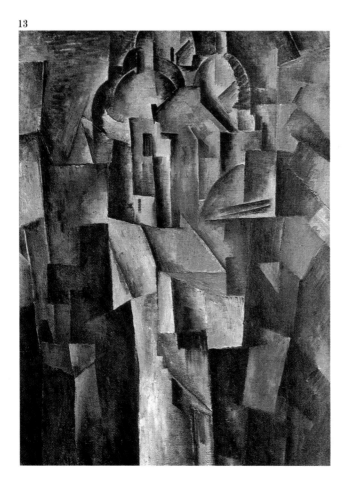

12 Pitcher, Bottle, and Lemon, *1909. This still life is heavily indebted to the spatial investigations of Cézanne, which spurred Braque to "invent" Cubism. While the angular forms and the distorted perspective evolved from the work of Cézanne, the limited color palette is already typical of Cubism.*

13 Sacré-Cœur at Montmartre, *1910. Here Braque has reduced the identifiable elements of this well-known church to a rough-hewn outline of two domes. Only the title allows its recognition, and for this and other similar works from the same period some authors have used the label "Hermetic Cubism."*

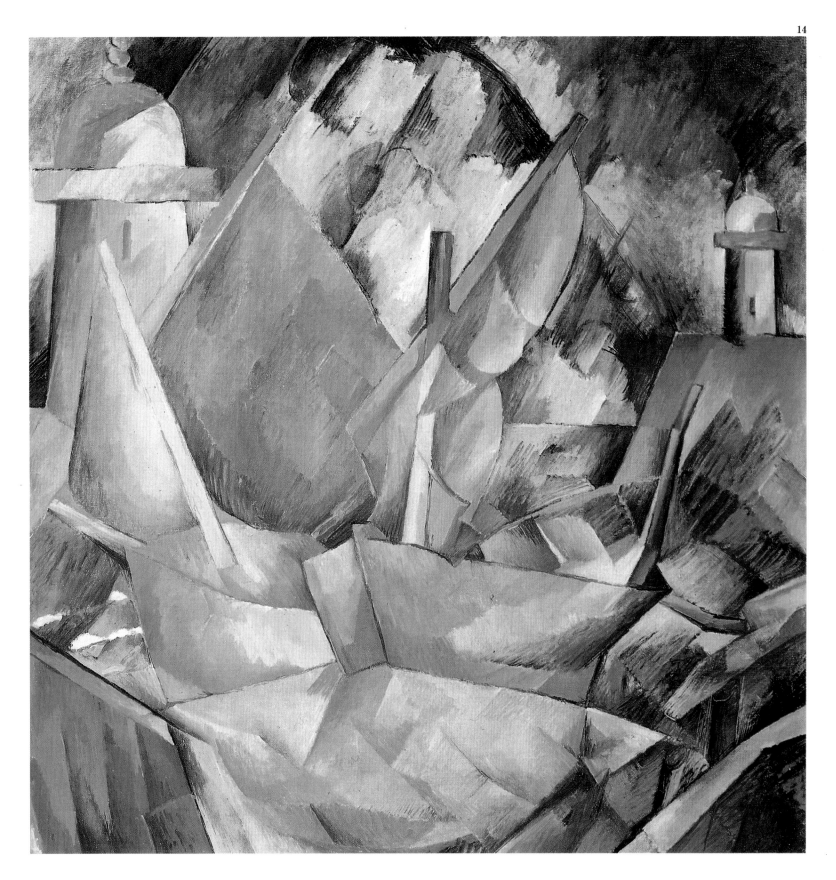

14 Harbor in Normandy, *1909. In this painting Braque has clearly distanced himself from Cézanne. The motif vanishes, not as a consequence of the radical process of schematization, but because the whole composition is divided into planes of color, each one of its elements receiving identical treatment.*

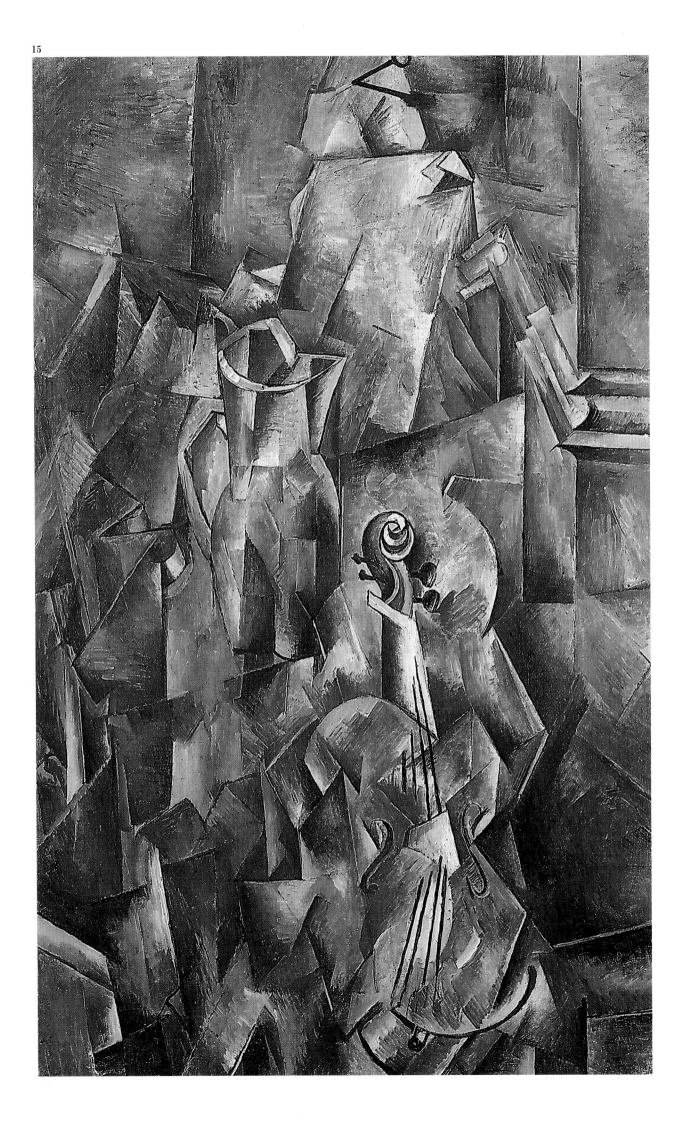

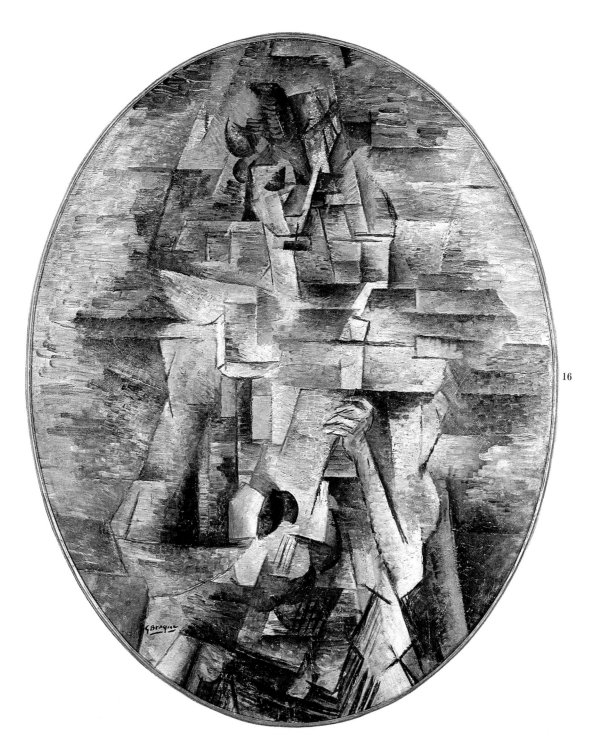

16

15 Pitcher and Violin, *1909–10. A good example of Cubist painting from the Analytical phase, this painting's motif unfolds in a series of faceted planes whose density is greater at the center of the pictorial surface. A few naturalistic traits enable the identification of the theme, at times with a touch of irony, as in the case of the nail and its trompe l'œil shadow along the upper border of the canvas.*

16 Woman with a Mandolin, *1910. Braque often adopted an oval format for his paintings, creating a classical and balanced composition. Instead of using color, already reduced here to a minimum of tones, Cubism structured the pictorial surface by means of lines, which in this work are almost exclusively horizontal.*

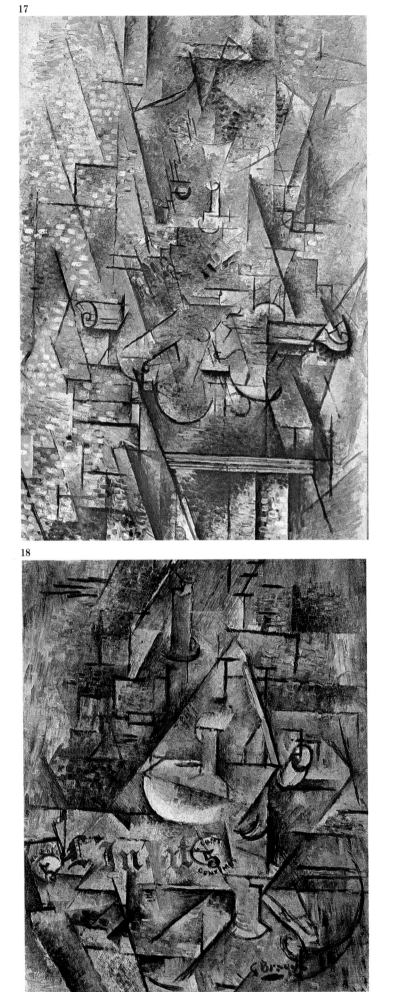

18

17, 18 Still Life with a Violin, *1911;* The Candlestick, *1911. One distinctive feature of Braque's paintings from this period is his application of color with tiny brushstrokes, reminiscent of the Pointillist technique. However, unlike Georges Seurat and his followers, Braque did not employ this method as a means of breaking down color, but rather as a way to texturize the pictorial surface and to generate a certain vibration.*

19, 20 Violin: "Mozart/Kubelick", *1912;* Still Life with a Bunch of Grapes, *1912. Braque was the first one to use stenciled letters as one of the many symbolic elements commonly adopted by Cubism. They were meant to act as a vehicle for reintroducing some vestiges of reality into the painting, a reality from which both he and Picasso had intentionally distanced themselves in the works from the so-called Hermetic phase.*

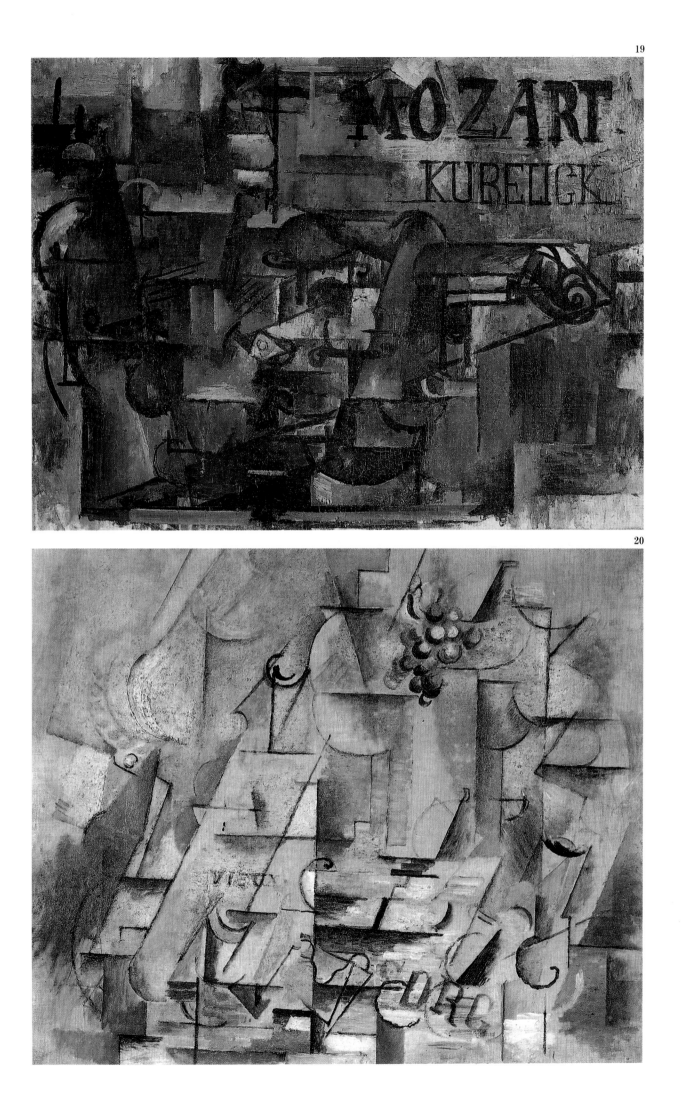

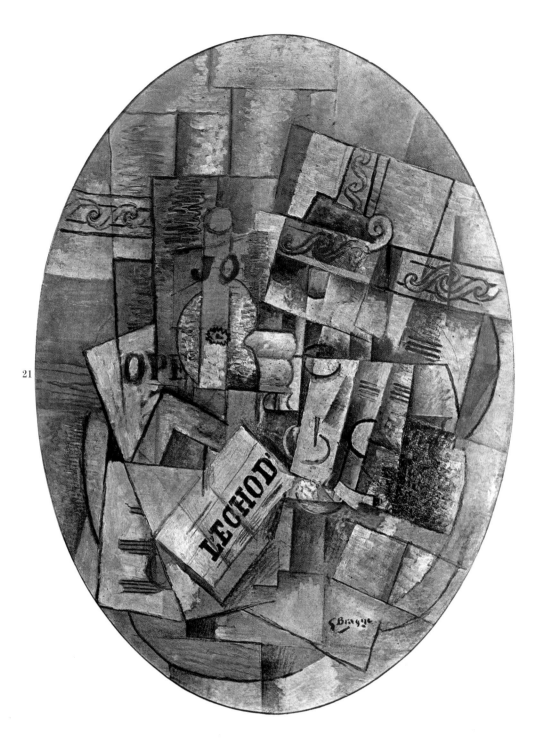

21

21 Pedestal Table, *1913. According to the poet Guillaume Apollinaire: "Picasso and Braque introduced neon sign letters and other inscriptions into their works of art because, in a modern city, inscriptions, electric signs, and advertisements perform a very important artistic function." In general in Cubist paintings, these loose fragments are invested with a poetic force that is more intimately associated with literature than with the art of painting.*

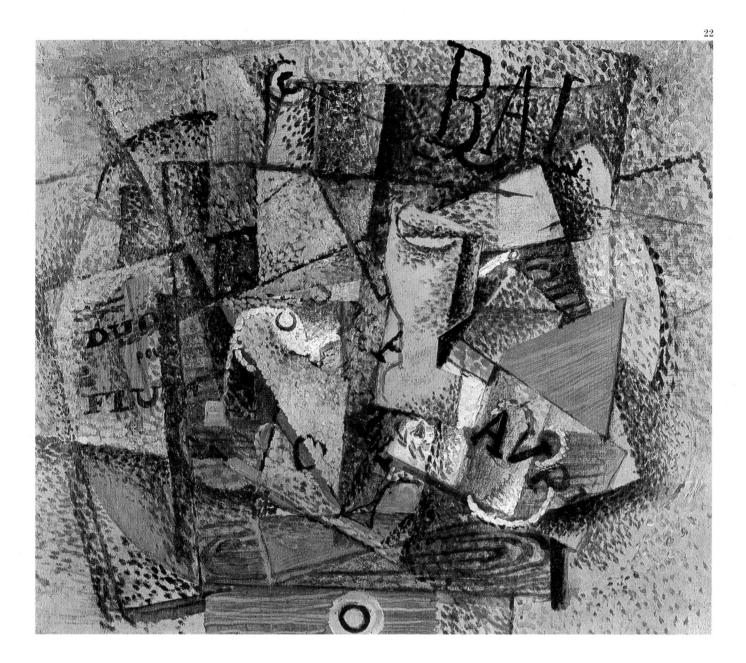

22 Glass, Bottle, and Pipe on a Table, *1914. References to the world of music are found consistently throughout Braque's oeuvre. The phrases "BAL" and "DUO POUR FLÛTES" are unmistakable allusions to two melodic variations that the painter combines here in a seemingly arbitrary and subjective manner.*

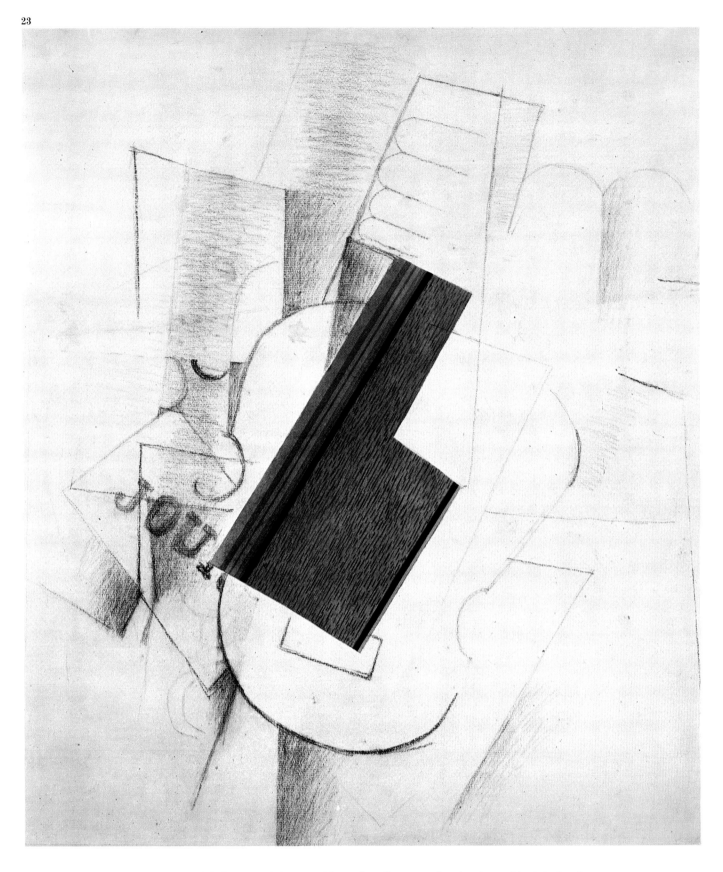

23 The Guitar, *1912. This work being one of Braque's earliest examples of* papiers collés, *it is therefore also one of the visually simplest: over a drawing representing a series of different planes, in which the outline of the guitar is sketched, the painter pasted a scrap of paper that imitates wood, suggesting that the guitar is made of that material.*

24 Guitar and Program: "Statue d'Epouvante", *1913. In the years when Braque created* papiers collés, *his artistic idiom became increasingly complex with each new work. In this case, the painter introduced four different types of paper, including an ad for a movie theater whose text is clearly legible. The fact that the movie advertised is a horror film adds an ironic twist to the composition.*

25 Ace of Hearts, *1914. In this work, by leaving the oval shape suspended over the dun surface of the background, Braque has created a very peculiar piece. The cutout patterns in the white paper endow the composition with an increased sense of depth and a certain relief quality, foreshadowing some of the devices that would become common tools of Cubist sculpture.*

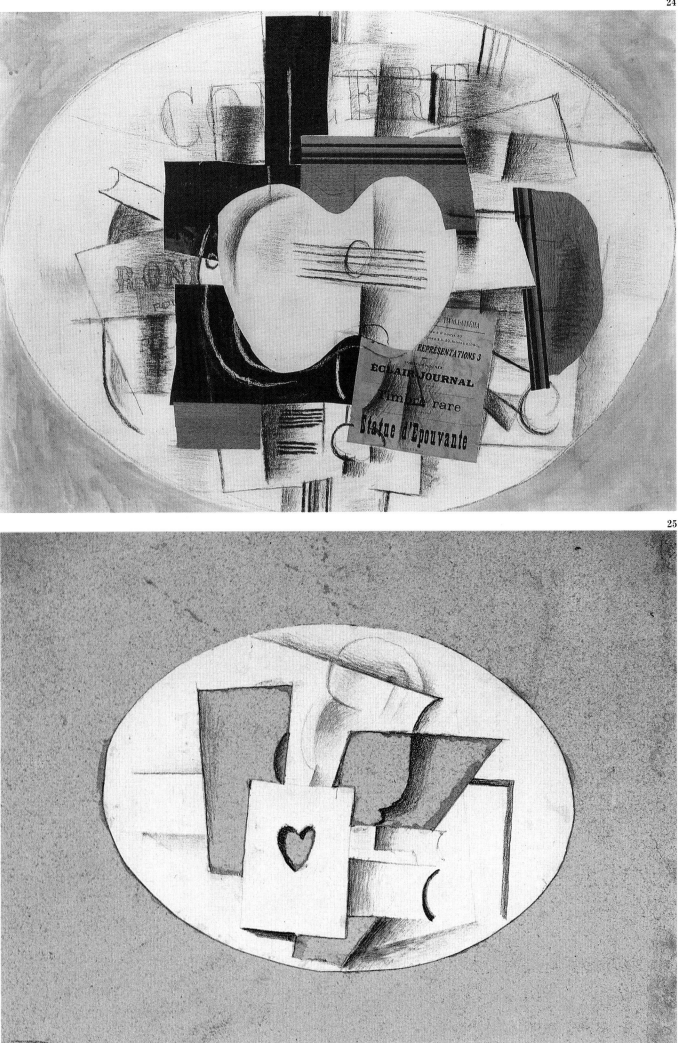

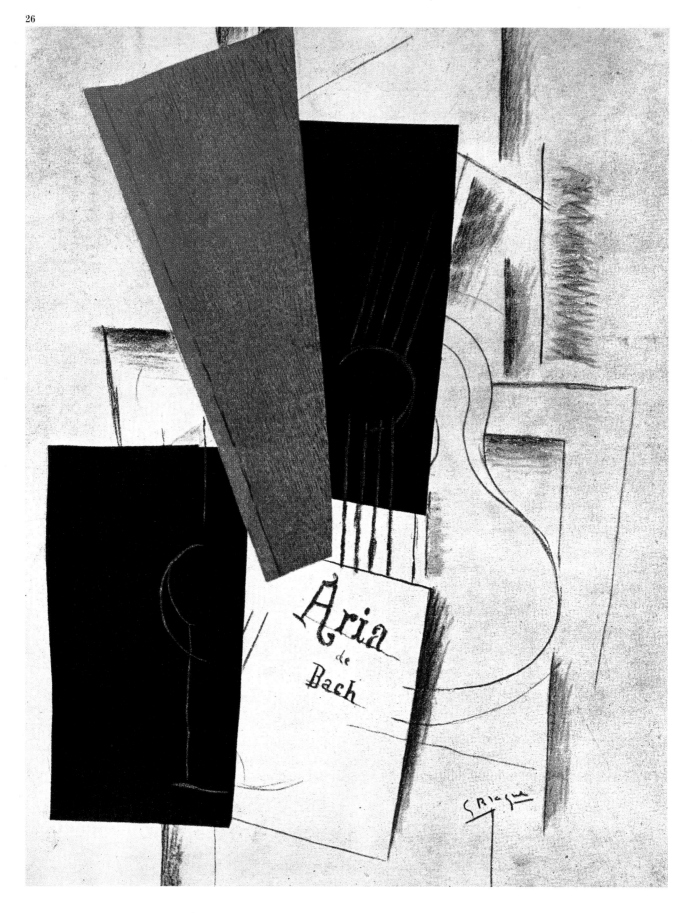

26 Aria de Bach, *1912–13. The spare construction of this* papier collé *seeks to establish a visual parallel with the music of Johann Sebastian Bach. The fact that the drawing does not extend over the piece of paper imitating wood generates a sensation of space without any depth.*

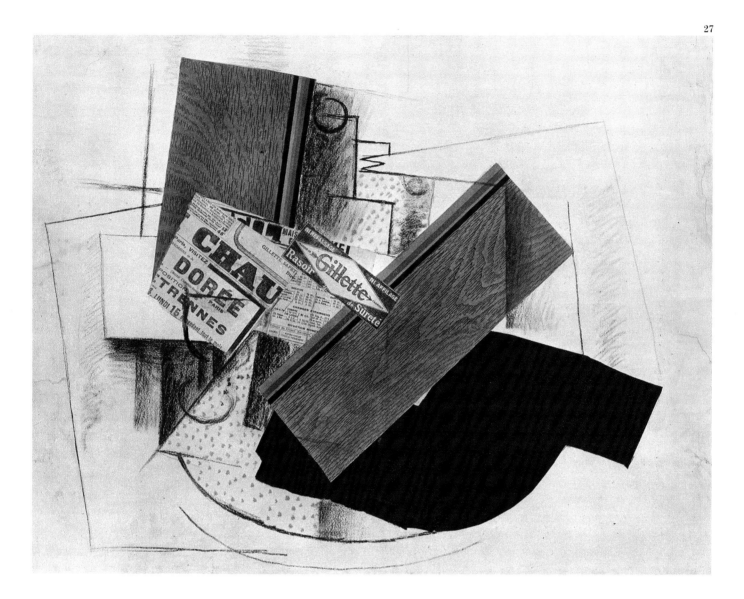

27 Still Life on a Table: "Gillette", *1914. Here Braque has introduced into the painting a clipping from a newspaper as well as the wrapping of a razor blade. Once separated from their habitual context, all of these fragments acquire an astounding poetic force, particularly since the words and phrases in the clippings are not a mere product of chance; in fact, they produce a number of puns, for which both Braque and Picasso always exhibited a definite fondness.*

A Foray into Classicism

The outbreak of World War I and Braque's induction into the armed forces marked the end of the painter's friendship with Picasso, as well as to their artistic collaboration. In 1915, Braque sustained a serious head injury in the line of duty and, as a result, could not resume painting until 1917. A banquet was held in Paris to celebrate his recovery, and, in the summer months, he was able to take up his work again. In his first paintings after the war, Braque carried on the simple designs of Synthetic Cubism, albeit in a more somber tonality. Between 1929 and 1936, he worked on *The Canephorae*, a series of large, Greek-inspired canvases and drawings picturing female nudes carrying baskets of fruits and flowers. Braque's images may have been influenced by Picasso, who had a similar "classical" phase, or even more likely by Pierre-Auguste Renoir, whose last large nudes had been shown in a retrospective exhibition at the Salon d'Automne of 1920. While the countenance of Braque's figures is more closely reminiscent of the Greek model than Picasso's, who derived his instead from the example of Roman statuary, Braque's two-dimensional drawing and positioning of the human figure are typically replete with unexpected spatial discoveries.

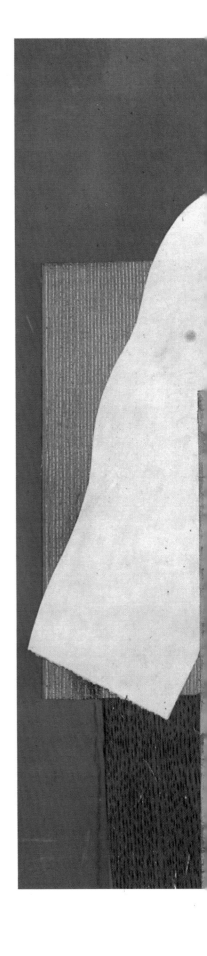

28 Guitar and Clarinet, *1918. This work may be regarded as one of Braque's last* papier collé *masterpieces. Unlike similar works from the years before World War I, here the drawing element is missing, leaving Braque to represent the casted shadows with cutouts of black paper.*

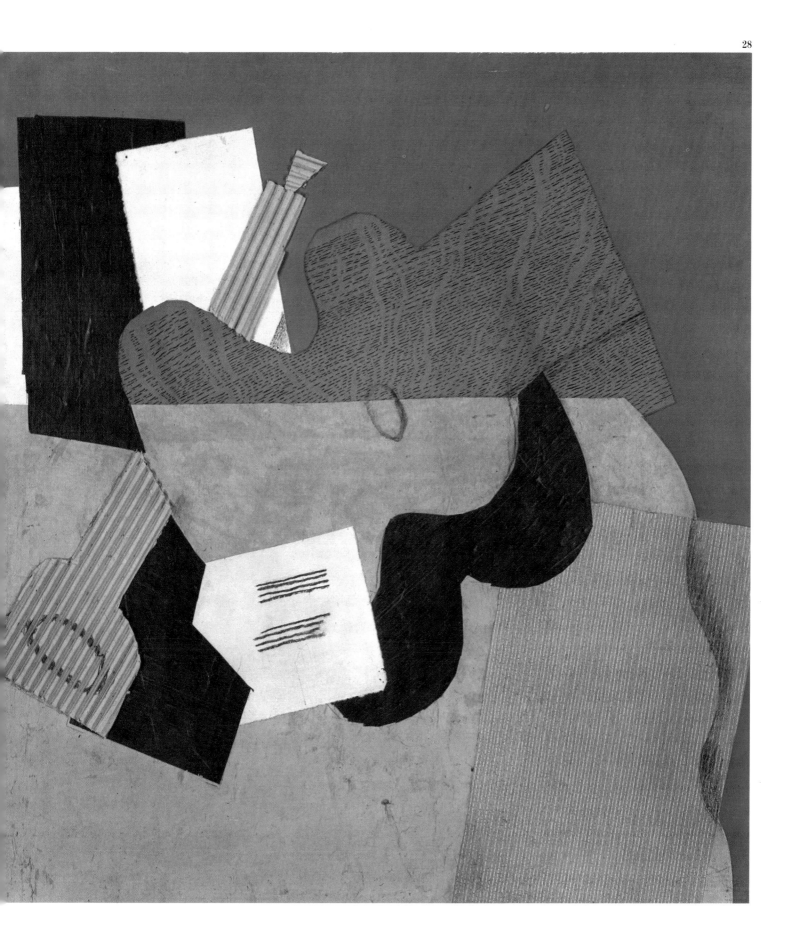

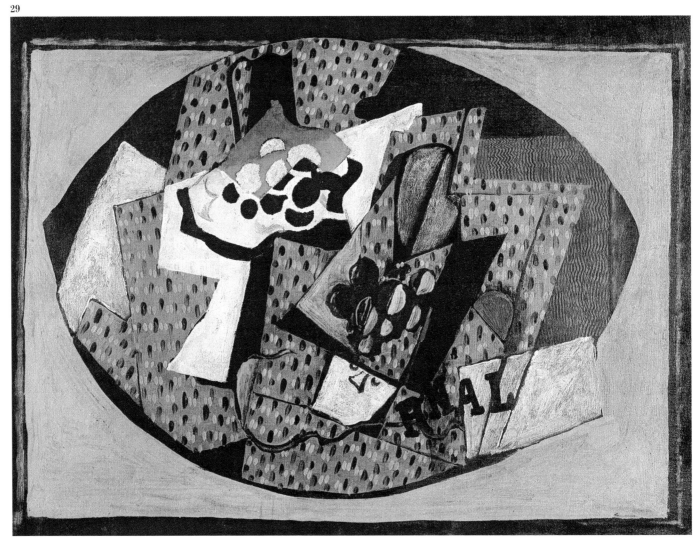

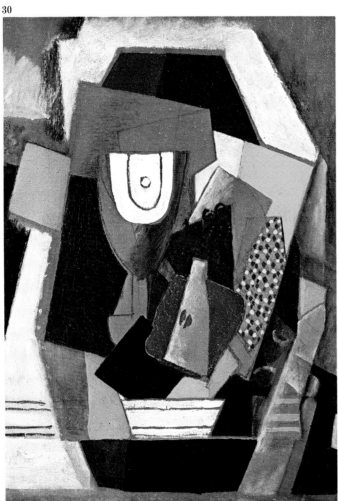

29, 30 Still Life with Grapes, *1918;* Vase and Pear, *1918. These works are good examples of Braque's "return to painting" during the last year of the war, as by this time he felt the road of the* papier collé *had been sufficiently explored. "Through repeated use," he once said, "even ideas, like clothes, get worn and lose their shape."*

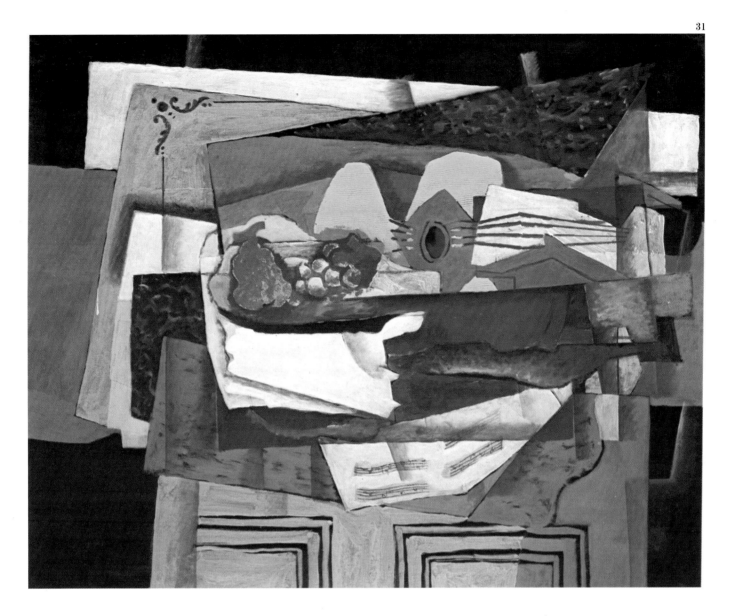

31 The Buffet, *1920. The exceedingly horizontal
direction of this painting is one of its most
suggestive features. While he had indeed expanded
the range of colors of his palette, Braque remained
loyal to the iconography found in his earliest Cubist
works: grapes, a guitar, and musical scores.*

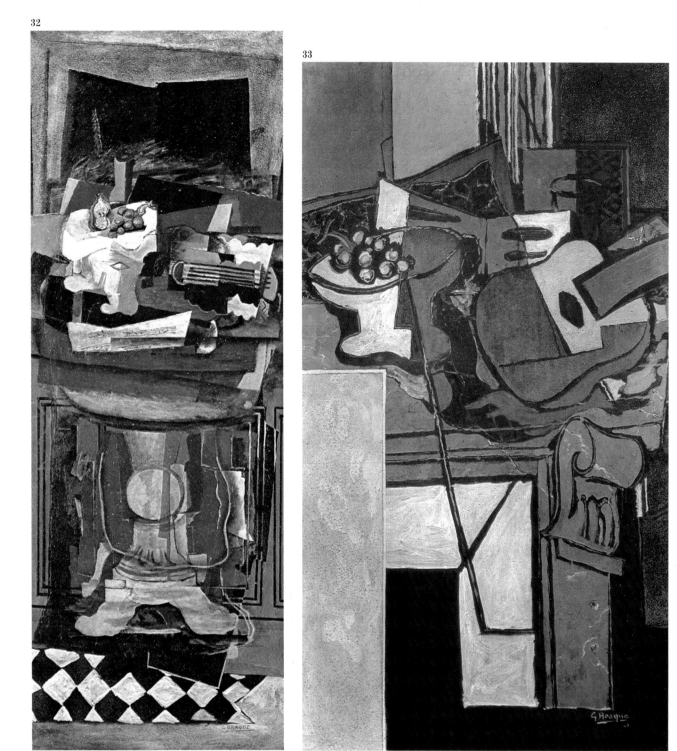

32, 33, 34 The Table (Le Guéridon), *1921–22;* The Fireplace, *1923;* Fruit on a Tablecloth with Fruit Dish, *1925. These large-format still lifes, whose complexity has induced some authors to label them "studio landscapes," share the same vertical distribution, and disjointed, broken-down planes inherited from Synthetic Cubism, the geometric swaths of color derived from* papier collé, *and the presence of perfectly recognizable objects drawn with exceptional sensibility.*

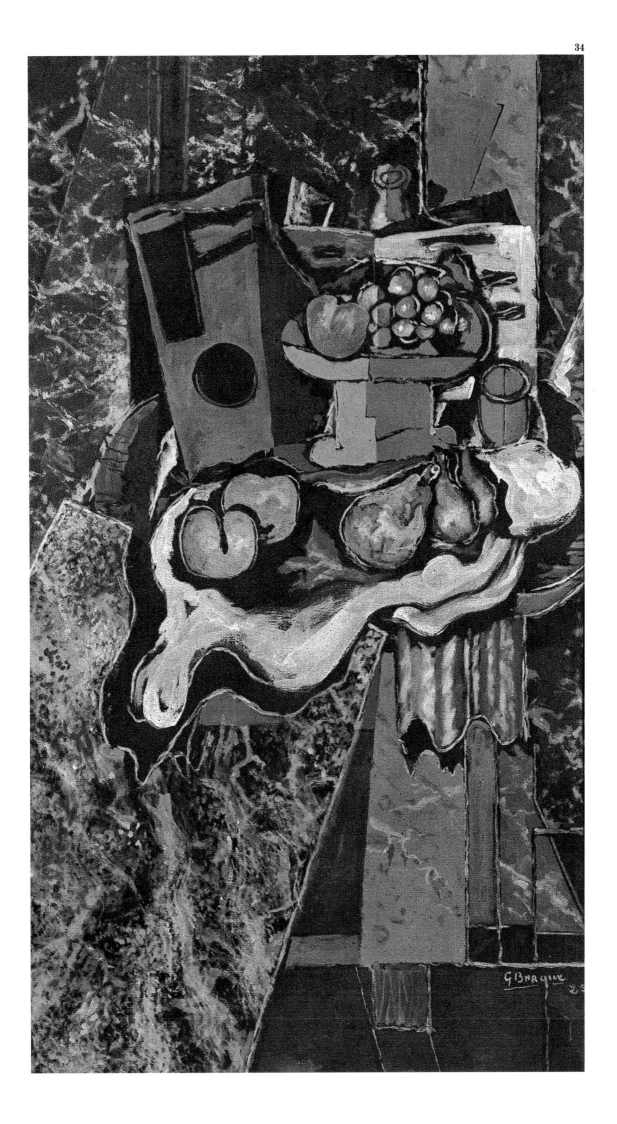

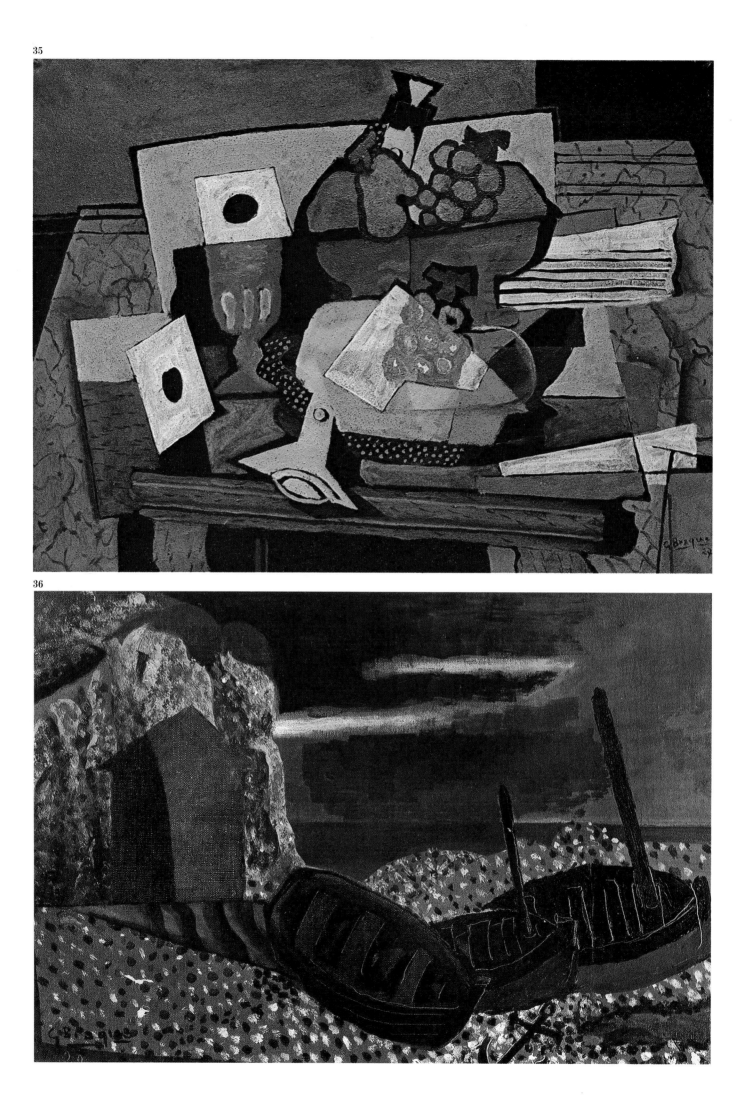

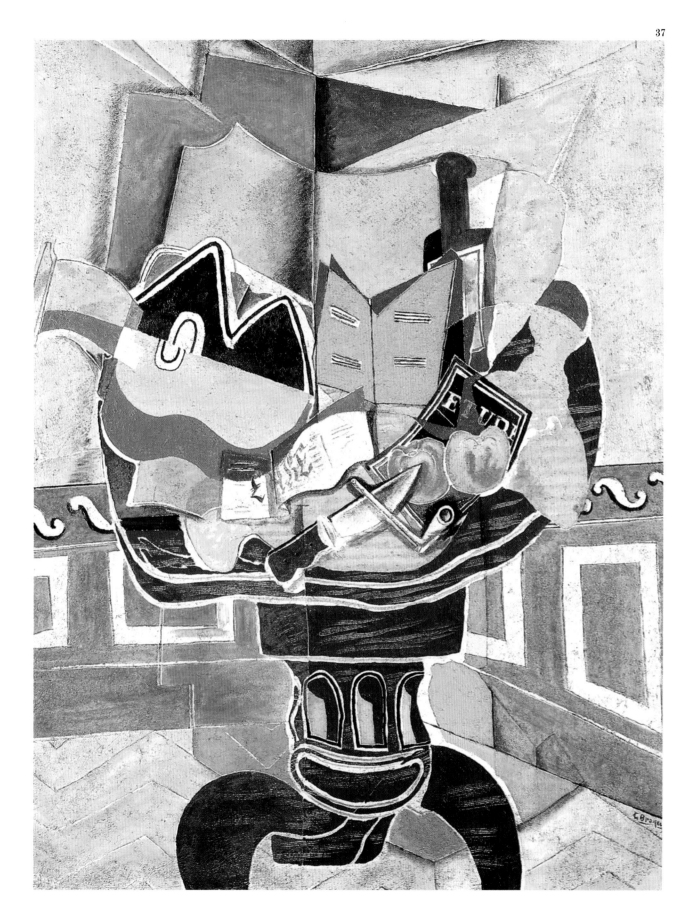

35, 37 Still Life with Clarinet, *1927; The Large Pedestal Table, 1929. Paintings such as these induced Alejo Carpentier to comment: "From a decorative point of view, nothing is more pleasurable than any one of Braque's Cubist compositions. However, the decorative aspect in Braque's oeuvre is never a shortcoming, since his canvases always possess something more."*

36 *The Beach at Dieppe, 1929. In the late 1920s, Braque again began to paint landscapes, a genre he had not treated since 1911. For the most part, these works depict the seashore, as their execution coincided with the artist's return to Normandy, where he had lived as a child. The lack of depth in this nocturnal scene creates a peculiar illusory sensation.*

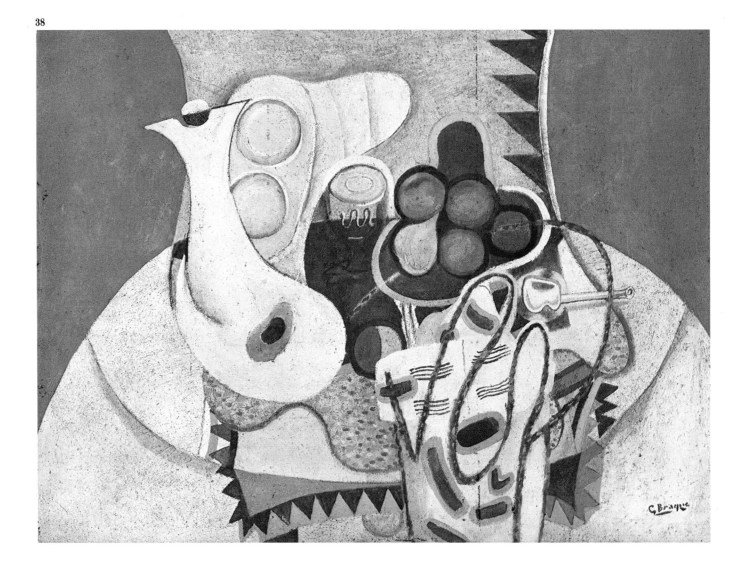

Color and Symbolism

In 1929, there appeared in Braque's oeuvre a type of composition that lasted through the first half of the 1930s, and whose humorous and forceful distortions bring to mind Picasso's output from the same period. In executing these works, Braque lay a special emphasis on drawing and color, in many ways reminiscent of both Picasso and Henri Matisse. Meanwhile, Braque also continued working with the Greek themes that had first emerged in his pictures during the 1920s, and which have been critically regarded as purely formal exercises in complex calligraphy, entirely devoid of any symbolic significance. The trauma of World War II eventually moved Braque to incorporate aspects of a more contingent reality into his work. The paintings of the *Vanitas* series, which he executed in those years, are permeated by death and suffering—not surprisingly—as Braque came to recognize that "artists are, to say the least, affected and modified by history." The liberation of Normandy and Paris in 1944 enabled the painter to embrace more heartening themes: flowers, billiard tables, garden chairs, and patios entered his creative universe, filling it with color and with gaiety.

38, 40 The Pink Tablecloth, *1933;* Still Life with Red Tablecloth, *1934. These two still lifes are evidence of Braque's renewed taste for vivid colors. These lively images, full of rounded and sinuous forms, were painted with pigments mixed with sand. The decorative quality can be traced to elements found in compositions by Matisse.*

39 Reclining Nude on a Table, *1931. The winds of Surrealism have clearly blown on this bizarre figure: an odalisque with the eye of a Cyclops and frail disproportionate arms—a travesty of the feminine figures of Ingres or Manet. The schematic arrangement of the figure and the curvaceous lines of the drawing are reminiscent of works painted by Braque's old friend, Pablo Picasso.*

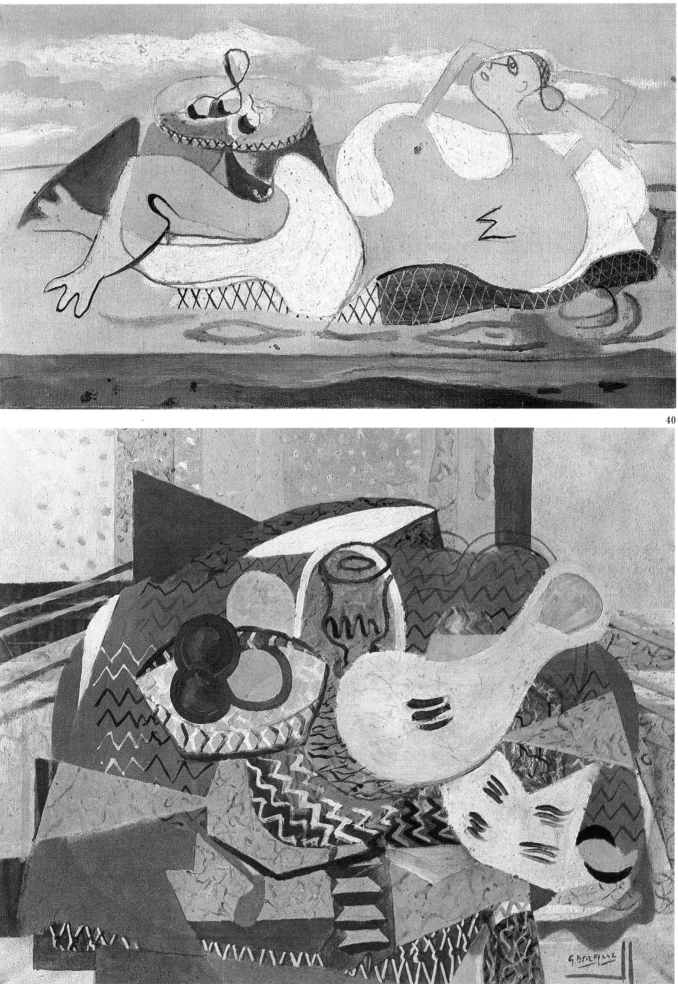

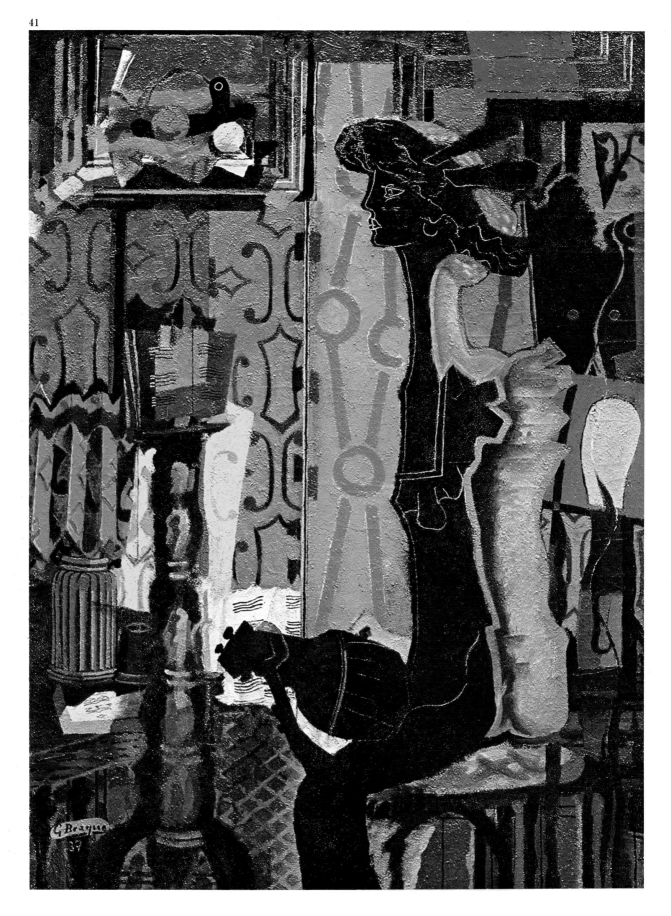

41 Woman with a Mandolin, *1937. This canvas belongs in a series of works that, until 1939, used painting and music as their pretext. Here, the vivid colors share the limelight with the blackness of the woman's silhouette.*

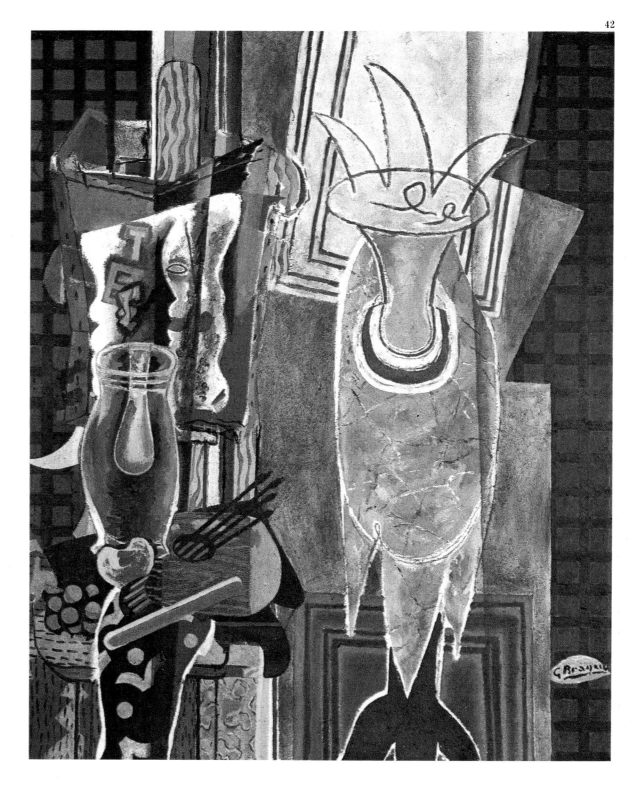

42 The Table (Le Guéridon), *1938. The composition unfolds in this painting as a succession of vertical stripes merely accommodating the objects in their midst. Here too is another example of Braque's skills as a decorator's apprentice in the simulation of the veins of marble in the table.*

43 The Painter and His Model, *1939. This canvas has been widely regarded as one of Braque's most important creations. Unlike Picasso in his works on the same theme, Braque has chosen not to depict himself in the painting. The shadows are a fundamental element of the composition, their profundity highlighting the image's predominantly ocher and green tones.*

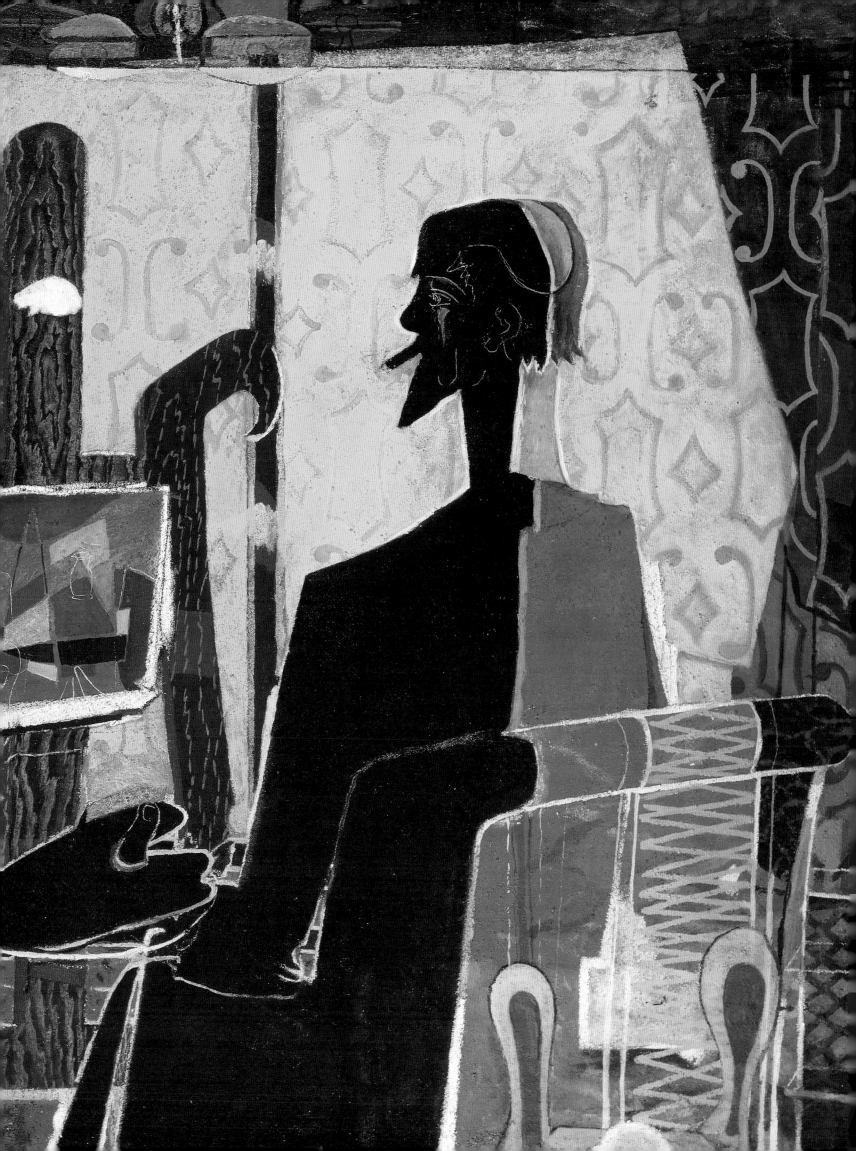

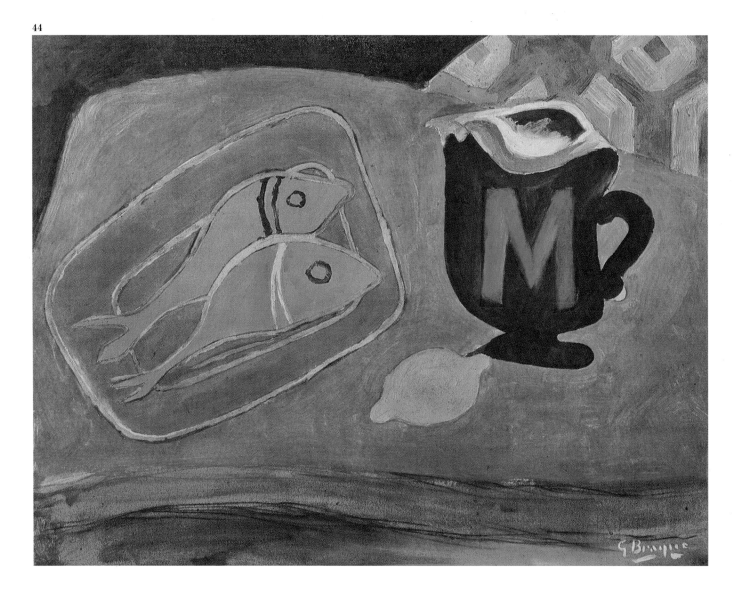

44, 45, 46 Two Mullets, *1940–41;* Bottle and Two
Fish, *1941;* Still Life with a Skull, *1941–45. During
World War II, Braque's themes evoked the anguish
and agony of the time. These three paintings belong
to a series called* Vanitas, *in which common objects
are portrayed with a style that is at once sober and
full of pathos.*

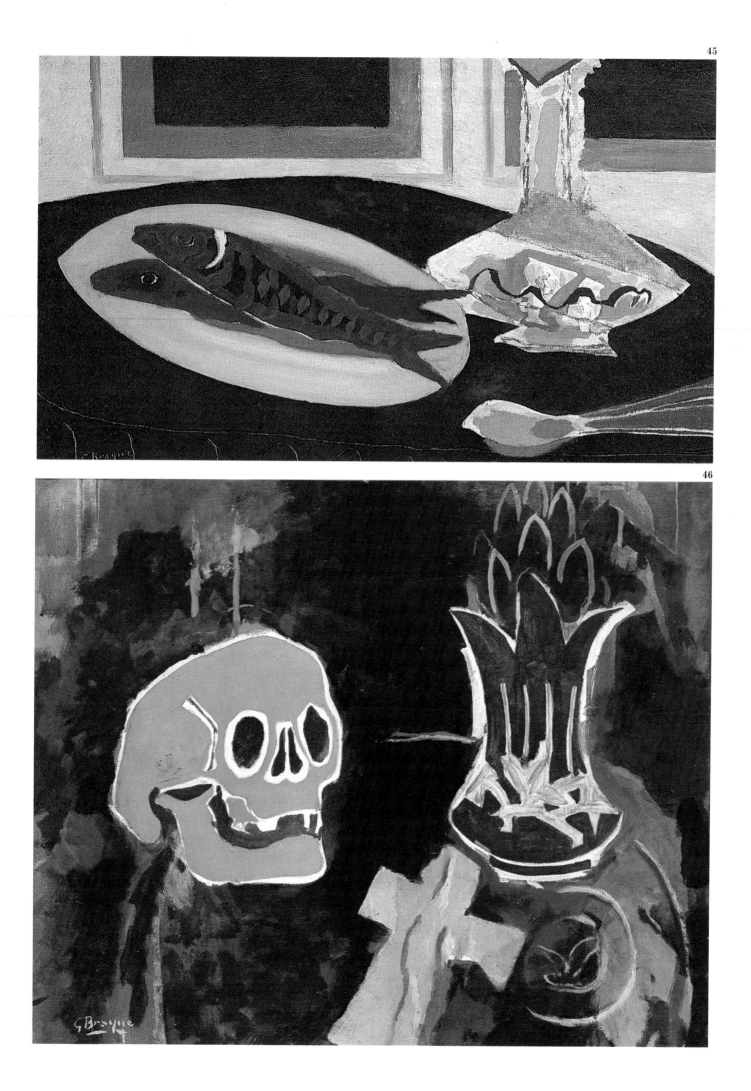

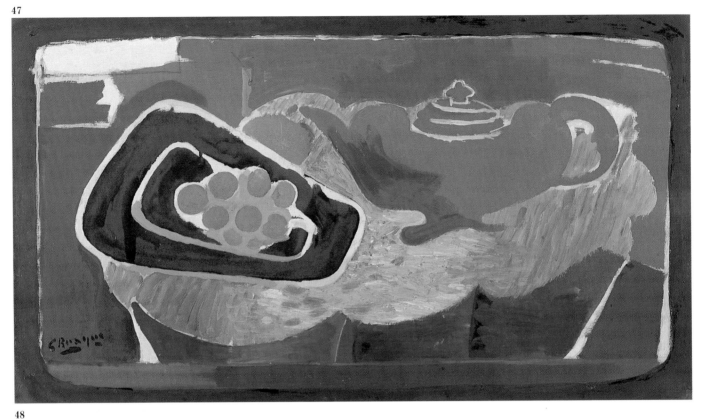

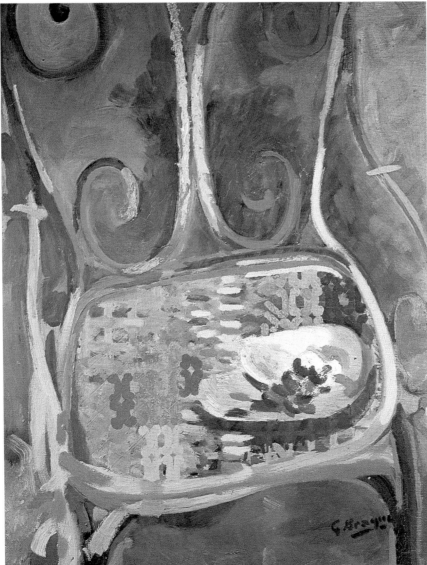

47 Teapot and Grapes, *1942. While Braque remained loyal to his own iconographic tradition throughout his career, the physical rendition of the objects in his paintings kept changing gradually. Here the colors are applied to the pictorial surface in a gliding motion with broad and elongated brushstrokes, sometimes creating monochromatic color fields.*

48 The Mauve Garden Chair, *1947–60. Once the war had ended, the distress and turmoil in Braque's work finally ceased. Around this time, he executed a number of paintings— this being a typical example—depicting garden chairs in a series of cheerful canvases, full of warm and vibrant colors, and characterized by a vigorous brushwork.*

49 Patience, *1942. This painting, shown in 1943 at the Salon d'Automne, is rife with symbolism. A woman with an anguished mien appears to be seeking an answer in the cards. It is at once a message of hope—it seems to encourage "patience in times of trouble"—and a card game by the same name, patience being another name for solitaire.*

50, 51 Man with a Guitar, *1942–61;* Man at an Easel, *1942. In spite of the increasing degree of symbolism that emerged in Braque's work during the war years, his foremost preoccupation remained painting itself. In these two pictures, the figures are viewed from behind as they face into the painting.*

50

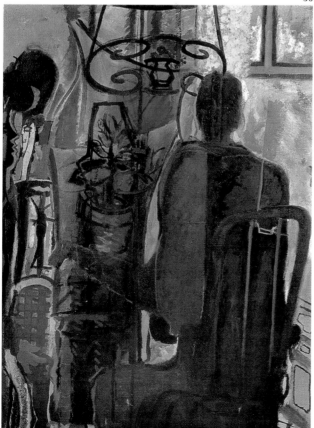

51

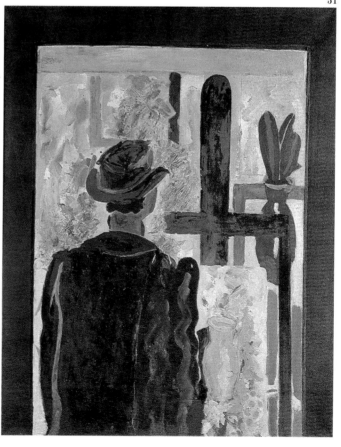

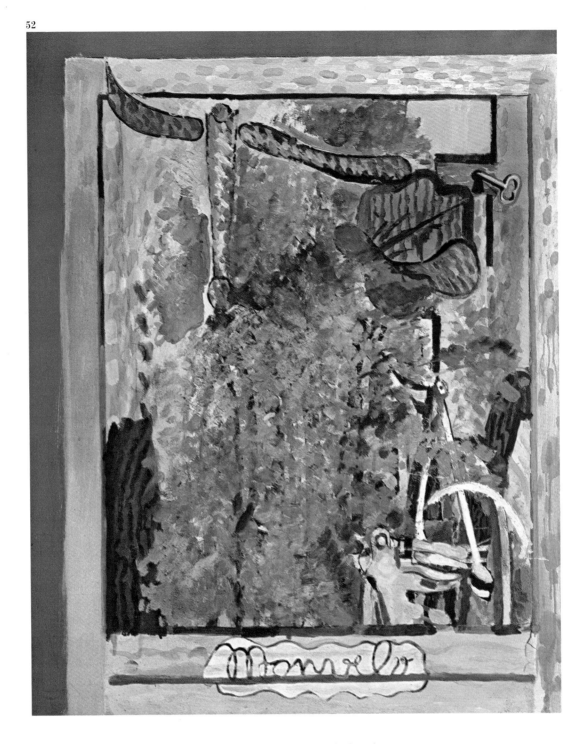

52 My Bicycle, *1941–60. A few paintings from the 1940s depict somewhat more rural motifs, uncommon in Braque's work to this point. Here, a bicycle emerges from a thicket while, in the upper right-hand corner, a key appears to protrude from the canvas itself. At the edge of this scene, the painted frame bears the humorous inscription "monvelo" (my bike).*

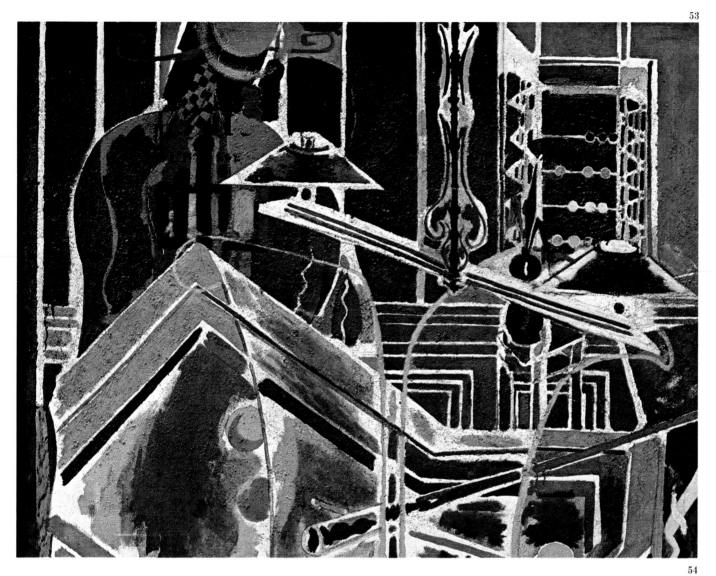

53 The Billiard Table, *1945. This work belongs in a series of paintings of billiard tables executed by Braque in the period marked by the Allied landing in Normandy and continuing until the year 1952. The pictorial space of these canvases appears to be devoid of colors, drenched as they are under the effect of artificial lighting. The use of intersecting straight lines confers an extreme degree of boldness on the drawing, while the plasticity of the forms is enhanced by the use of sand blended in with the pigment.*

54 The Salon, *1944. The sense of repose emanating from this domestic space is reflected by the gently waving lines of the objects represented in this scene. Albeit somewhat toned down by the preponderance of grayish hues, there is in this work a certain decorative aspect, which patently derives from the example of Matisse.*

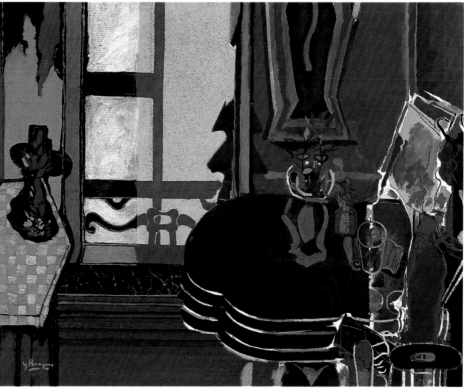

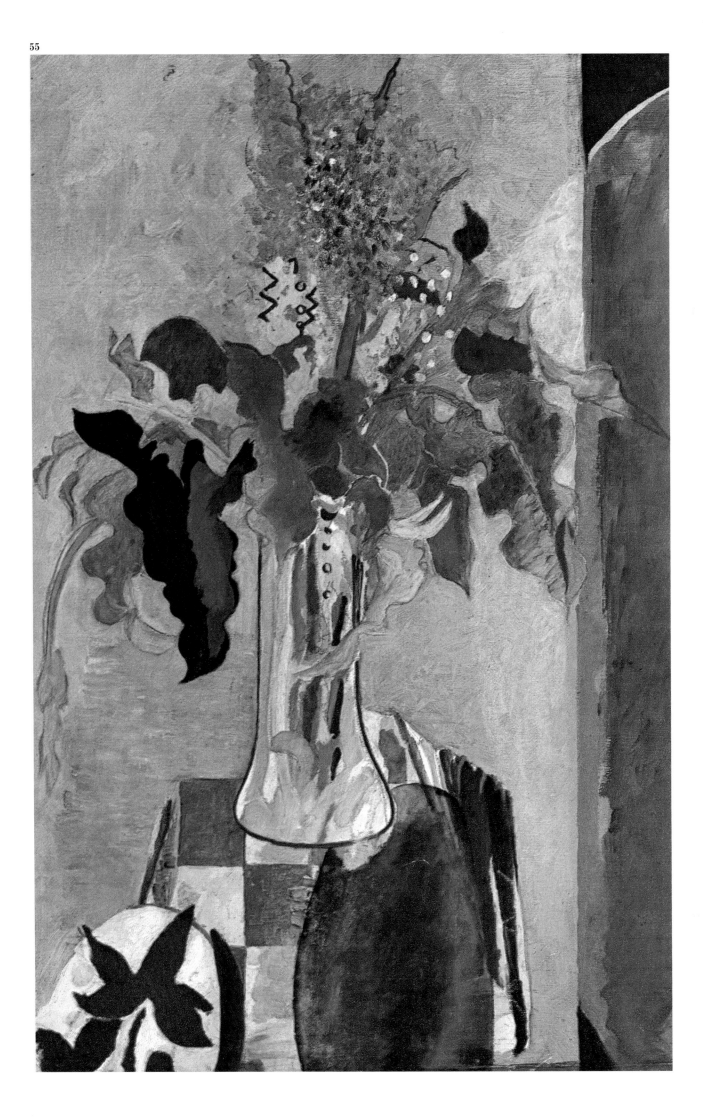

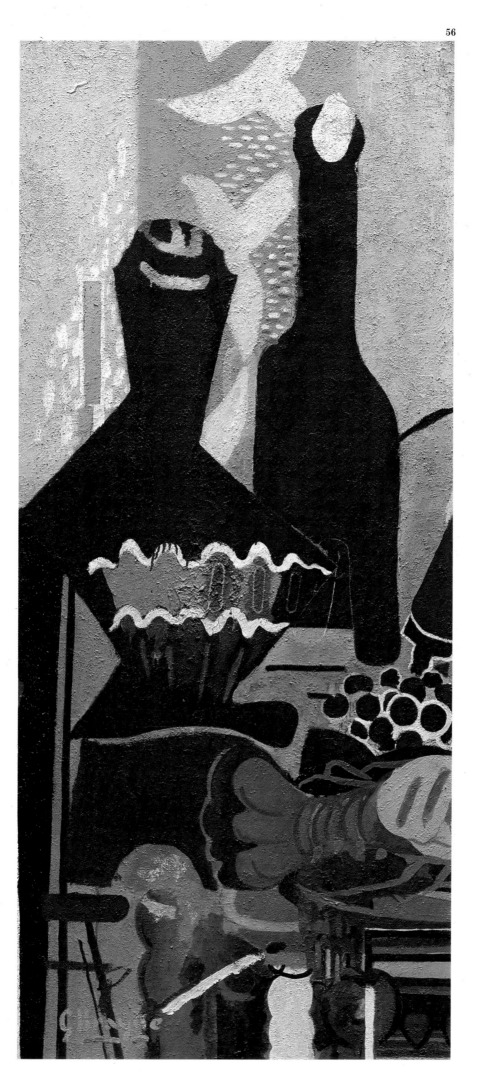

55 The Vase of Lilacs, *1946.
Here is yet another theme that
Braque frequented in his
painting after the end of World
War II. The flowers are always
full of light, rendered to such a
vivid and elegant degree that
they risk appearing
conventional.*

56 Still Life with a Lobster,
*1948–50. The tactile surface of
this picture—which Braque
painted with a blend of sand
and oil colors—enhances the
substantive quality of the
objects, in spite of the fact that
they are represented in uniform
colors and apparently are not
meant to establish any sense of
volume.*

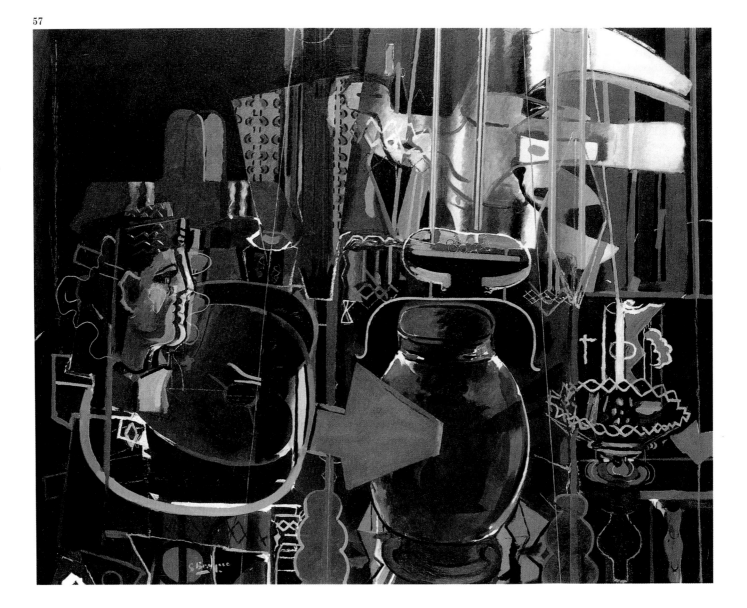

Space and Movement

In 1949, Braque set out to work on a series of canvases, each entitled *Atelier (Studio)*, which would occupy him for the following eight years. In these works, the physical structure of painting itself appears to be in motion. It was known that in the artist's studio there hung from nearly invisible wires several scraps of metal and a number of objects typically found in Braque's still lifes. The slowly spinning motion of these mobiles, appearing and disappearing, tracing their fine and delicate silhouettes in midair, inspired Braque to challenge the two-dimensional flatness of the canvas, setting the mobiles' painted equivalents in motion as well. By 1956, when he completed the last of his eight *Atelier* canvases, Braque had already immersed himself in the production of a new motif—paintings with birds—that he would stick with until the end of his life. "In my later creations," he once said, "I have been thoroughly engrossed in issues of space and movement." From mobiles to birds, Braque continued to seek ways to give shape to the concept of motion in space, including the simple and slender winged creatures for the ceiling of some rooms at the Louvre, which he was asked to decorate in 1952.

57, 58 Studio II, *1949;* Studio IX, *1952–56.*
Belonging in a series of eight large canvases, the Atelier *pieces introduce the viewer to the painter's innermost world, the very locus of his work and reflections—to a certain extent, the very essence of his art. "With age," Braque once said, "art and life become one."*

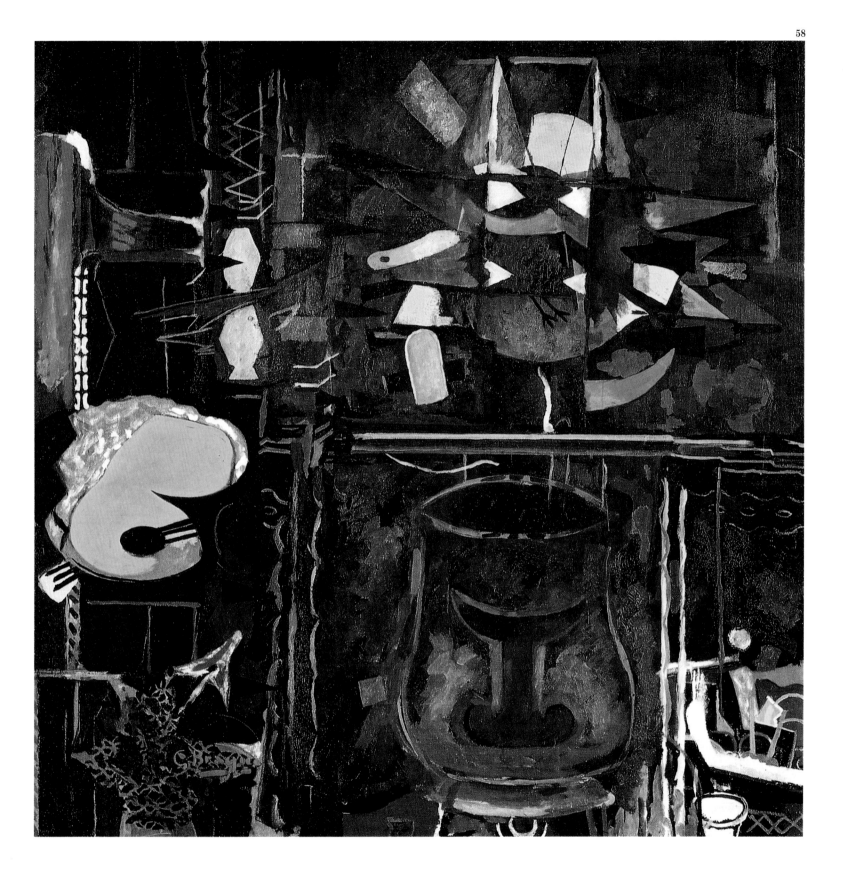

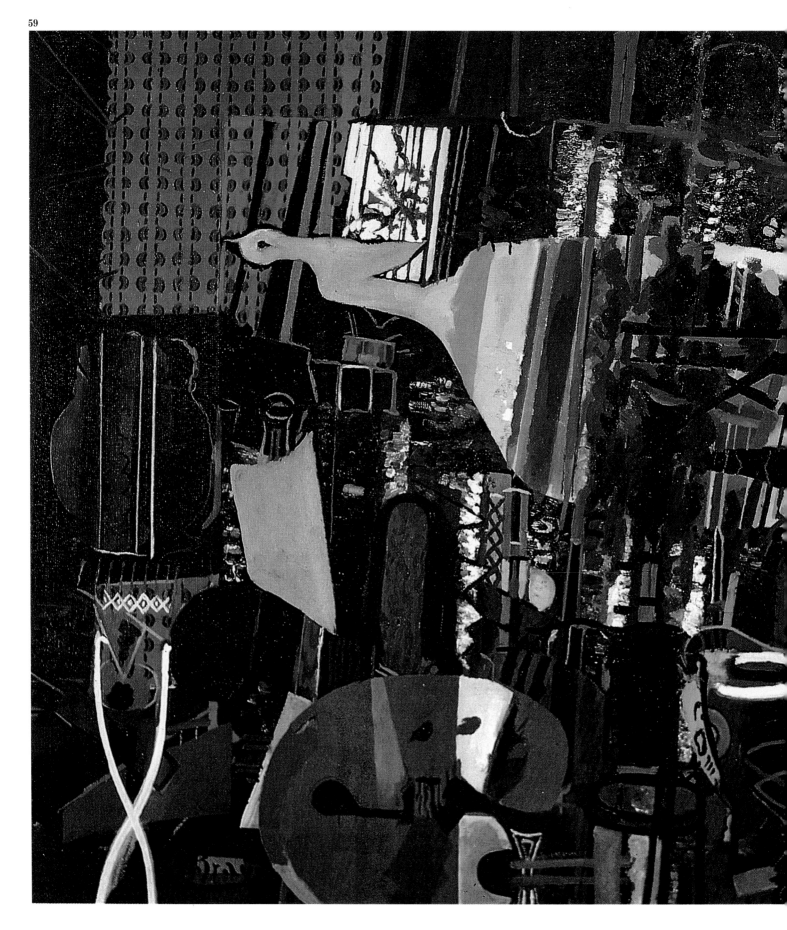

59 Studio III, *1949–51. In this canvas, a bird dominates the
space inside the artist's studio, dwelling in a composed and
conspicuous manner amidst a heap of barely recognizable objects
and signs. Meanwhile, a succession of overlapping surfaces
creates a turbulent, restless background.*

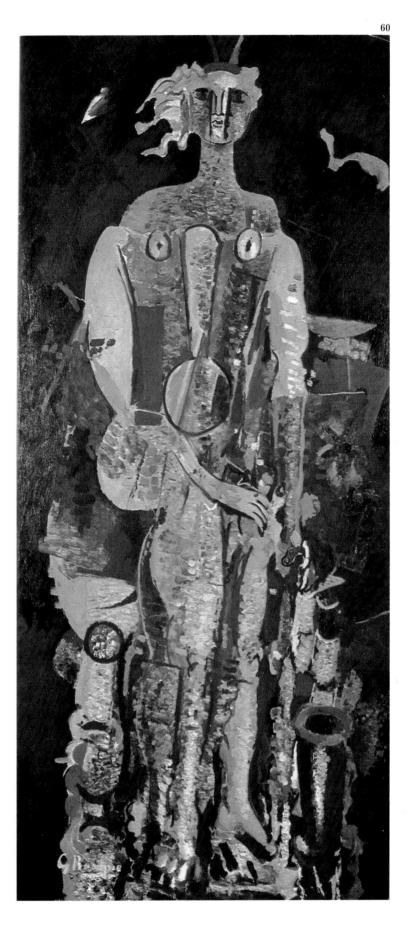

60 The Night, *1951. This large canvas marked the artist's return to mythological themes: a tall and haughty woman appears to be emerging from the primal chaos. The fragmented brushstrokes are reminiscent of Braque's earliest Cubist works.*

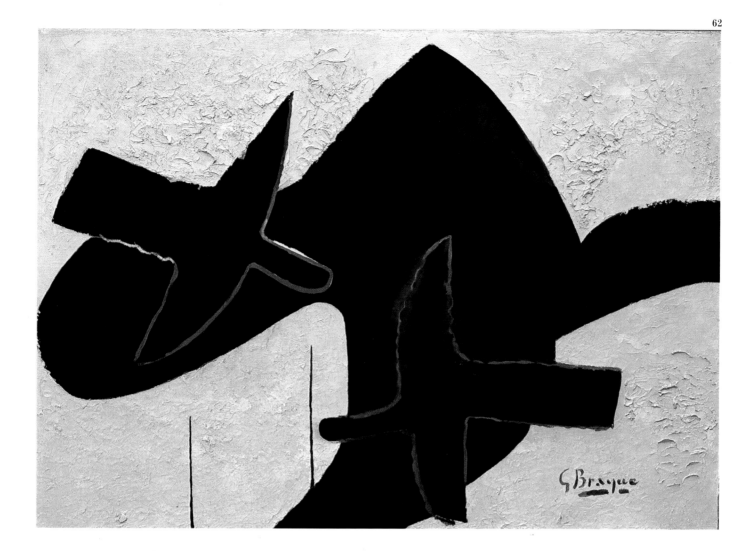

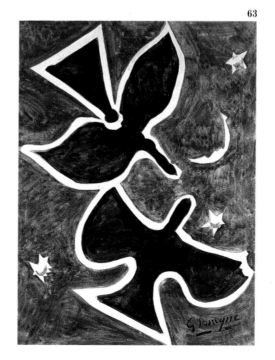

61 Bird in Squares, *1952–53. From the early 1950s to the time of his death in 1963, Braque painted a large number of works using birds as their theme. In none of these paintings did he attempt to realistically reproduce the flight of a bird; rather, he sought to give shape to motion in space.*

62, 63 Black Birds, *1956–57; Sketch for a ceiling at the Louvre, 1953. The forms of Braque's birds are invariably simple and schematic. They seem to be floating, rather than flying, through dense skies of blue. More than symbolic figures, Braque's birds should be viewed as painterly experiments.*

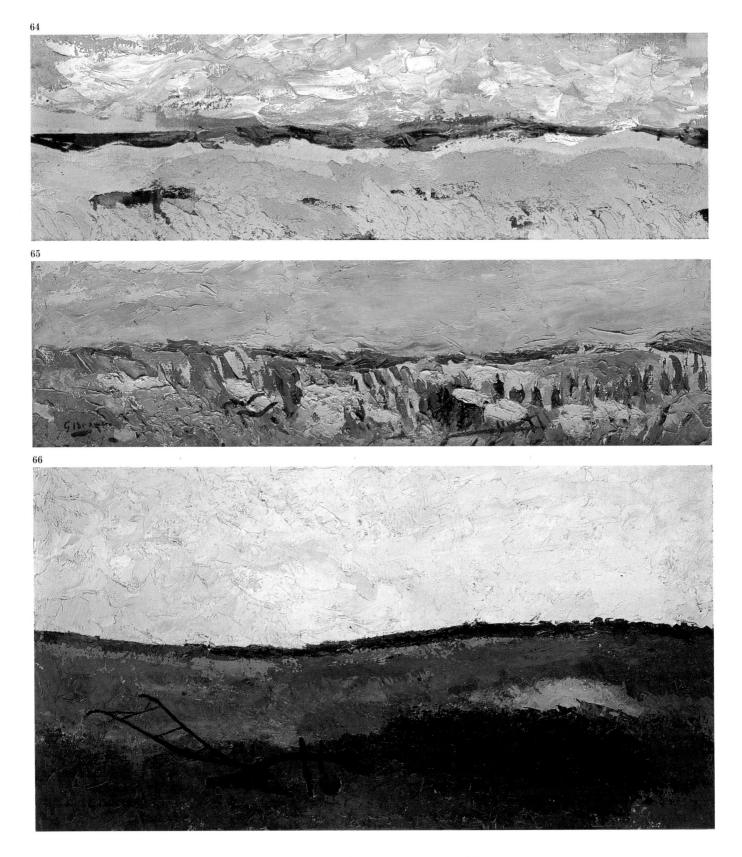

64, 65, 66 The Field of Colza, *1956–57;* Landscape, *1959;*
Landscape with Plow, *1955. In the last years of his life, Braque
resumed painting landscapes for the first time since his earliest
Fauvist works. The fertility of the soil and the mutable expanse of
the skies and clouds are mirrored in the thick, sensory brushwork
of the canvas: "Driven by the desire to advance further in the
expression of spatial reality, I wanted to turn brushwork into a
new material."*

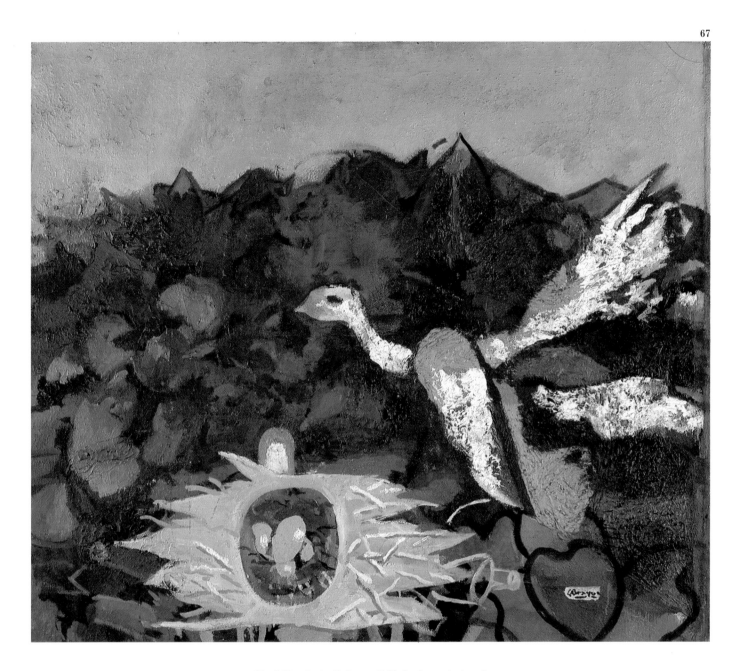

67 A Nest in the Foliage, *1958. In the majority of the works that Braque executed in this period, the blend of pigments with sand and other materials possesses the visual and tactile density of a fresco painting. Such is the case with this picture, in which the forms appear to have been molded rather than painted over the canvas.*

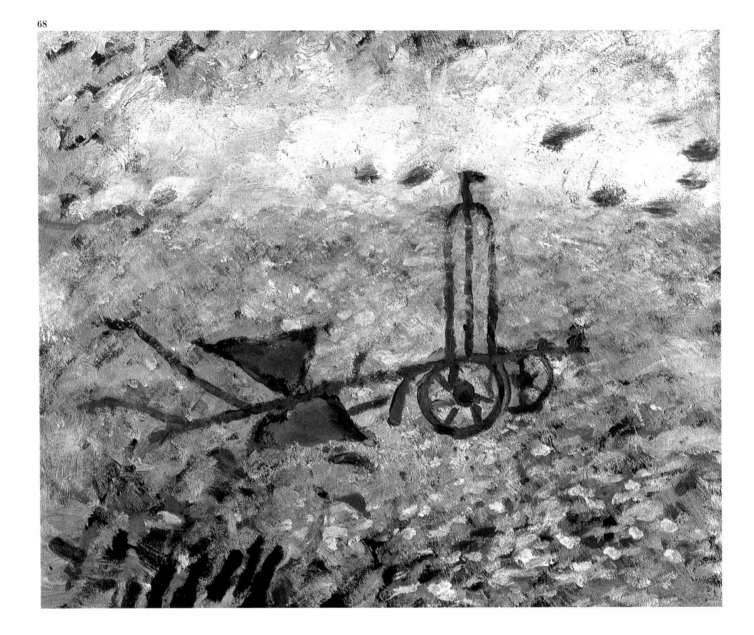

68 The Metal Plow, *1962. During the last years of Braque's life, the plow, rendered with elongated strokes of the palette knife, became an increasingly ubiquitous theme in his paintings, invariably treated as an emblem emerging from both matter and time. In 1961, Braque said: "I have plowed a furrow, I have opened a path for myself, in which I have advanced slowly but steadily in the same investigation . . . establishing a line of continuity."*

69, 70 Birds in Flight, *1960;* Bird in the Foliage, *1961. With each new rendering, Braque's birds became progressively more schematic. Reduced to forms on the plane, lacking volume or depth, they nonetheless attained extraordinary expressive heights. In the case of the lithograph* Bird in the Foliage, *Braque clearly intended to allude to his own earlier* papier collé *pieces.*

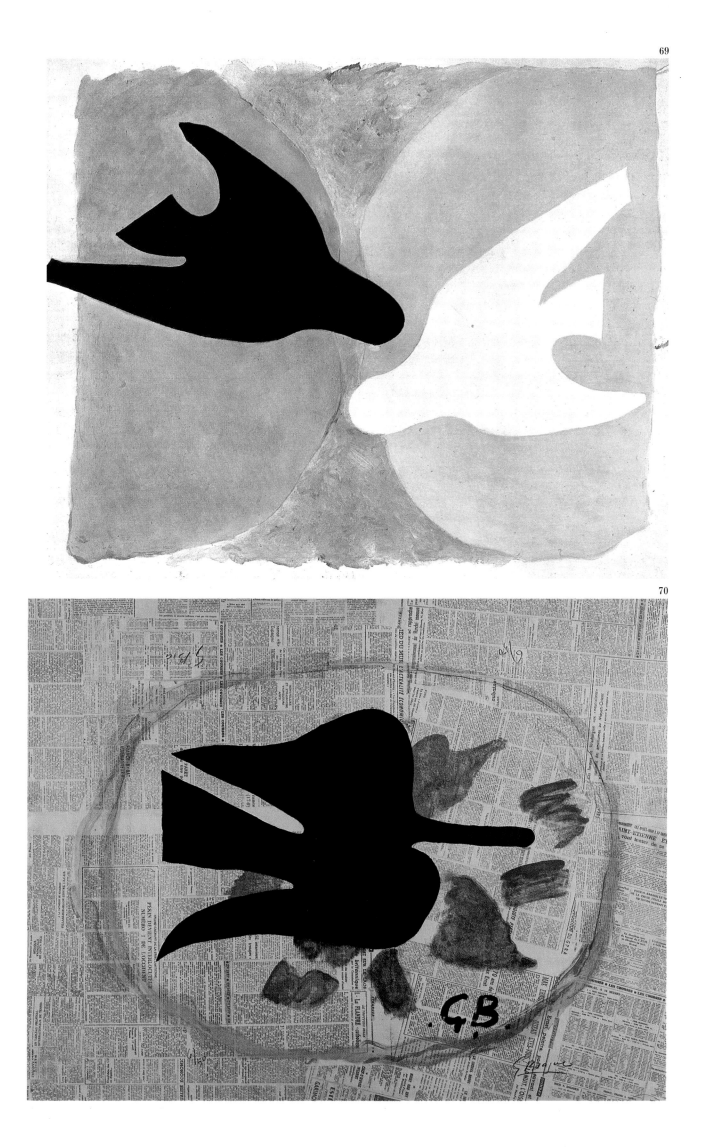

List of Plates

1 The Harbor at Antwerp, *1906. Oil on canvas, 15 × 18⅛″ (38 × 46 cm). Von der-Heydt-Museum, Wuppertal*

2 The Port of L'Estaque, *1906. Oil on canvas, 14⅝ × 18⅛″ (37 × 46 cm). Private collection*

3 The Port of Amberes: The Mast, *1906. Oil on canvas, 18⅛ × 15″ (46 × 38 cm). Galerie Beyeler, Basel*

4 Landscape at L'Estaque, *1906. Oil on canvas, 19⅝ × 24″ (50 × 61 cm). Private collection*

5 Landscape at L'Estaque, *1906. Oil on canvas, 23¼ × 28⅜″ (59 × 72 cm). Musée National d'Art Moderne, Centre Georges Pompidou, Paris*

6 Olive Tree near L'Estaque, *1906–07. Oil on canvas, 23⅝ × 28½″ (60 × 72.5 cm). Private collection*

7 Seated Nude as Seen from Behind, *c. 1907. Oil on canvas, 21⅝ × 18⅛″ (55 × 46 cm). Musée National d'Art Moderne, Centre Georges Pompidou, Paris*

8 Large Nude, *1907–08. Oil on canvas, 55¼ × 40⅛″ (142 × 102 cm). Alex Maguy Collection, Paris*

9 Viaduct at L'Estaque, *1907. Oil on canvas, 25⅝ × 31⅞″ (65 × 81 cm). The Minneapolis Institute of Arts*

10 L'Estaque Landscape, *1908. Oil on canvas, 31⅞ × 25⅝″ (81 × 65 cm). Kunstmuseum, Basel*

11 Viaduct at L'Estaque, *1908. Oil on canvas, 28½ × 23¼″ (72.5 × 59 cm). Musée National d'Art Moderne, Centre Georges Pompidou, Paris*

12 Pitcher, Bottle, and Lemon, *1909. Oil on canvas, 18⅛ × 15″ (46 × 38 cm). Stedelijk Museum, Amsterdam*

13 Sacré-Cœur at Montmartre, *1910. Oil on canvas, 21⅞ × 16⅛″ (55.5 × 41 cm). Musée d'Art Moderne, Villeneuve-d'Ascq*

14 Harbor in Normandy, *1909. Oil on canvas, 31⅞ × 31⅞″ (81 × 81 cm). Art Institute of Chicago*

15 Pitcher and Violin, *1909–10. Oil on canvas, 46 × 28¾″ (117 × 73 cm). Öffentliche Kunstsammlung, Kunstmuseum, Basel*

16 Woman with a Mandolin, *1910. Oil on canvas, 36 × 28½″ (91.5 × 72.5 cm). Bayerische Staatsgemäldesammlung, Munich*

17 Still Life with a Violin, *1911. Oil on canvas, 51⅛ × 35″ (130 × 89 cm). Musée National d'Art Moderne, Centre Georges Pompidou, Paris*

18 The Candlestick, *1911. Oil on canvas, 18⅛ × 15″ (46 × 38 cm). Scottish National Gallery of Modern Art, Edinburgh*

19 Violin: "Mozart/Kubelick", *1912. Oil on canvas, 18⅛ × 24″ (46 × 61 cm). Private collection, Basel*

20 Still Life with a Bunch of Grapes, *1912. Oil and sand on canvas, 23⅝ × 28¾″ (60 × 73 cm). Musée National d'Art Moderne, Centre Georges Pompidou, Paris*

21 Pedestal Table, *1913. Oil on canvas, 35⅞ × 28″ (91 × 71 cm). Private collection*

22 Glass, Bottle, and Pipe on a Table, *1914. Oil on canvas, 18⅛ × 21⅝″ (46 × 55 cm). Mattioli Collection, Milan*

23 The Guitar, *1912. Collage on paper, 27⅝ × 23⅞″ (70.2 × 60.7 cm). Private collection*

24 Guitar and Program: "Statue d'Epouvante", *1913. Charcoal, gouache, and pasted paper, 28¾ × 39⅜″ (73 × 100 cm). Formerly, Picasso Collection. Private collection*

25 Ace of Hearts, *1914. Pencil and pasted paper on cardboard, 11¾ × 16⅛″ (30 × 41 cm). Private collection, Basel*

26 Aria de Bach, *1912–13. Charcoal and wood-pattern paper pasted on paper, 24⅜ × 18⅛″ (62 × 46 cm). National Gallery of Art, Washington, D.C.*

27 Still Life on a Table: "Gillette", *1914. Charcoal, pasted paper, and gouache, 18⅞ × 24⅜″ (48 × 62 cm). Musée National d'Art Moderne, Centre Georges Pompidou, Paris*

28 Guitar and Clarinet, *1918. Charcoal, gouache, paper, and corrugated cardboard, 30¼ × 37⅜″ (77 × 95 cm). Philadelphia Museum of Art, Arensberg Collection*

29 Still Life with Grapes, *1918. Oil on canvas, 19¼ × 27⅛″ (49 × 69 cm). Private collection, United States of America*

30 Vase and Pear, *1918. Oil on canvas, 18⅛ × 13″ (46 × 33 cm). Perls Galleries, New York*

31 The Buffet, *1920. Oil on canvas, 31⅞ × 39⅜″ (81 × 100 cm). Galerie Beyeler, Basel*

32 The Table (Le Guéridon), *1921–22. Oil and sand on canvas, 75⅝ × 28″ (192 × 71 cm). The Metropolitan Museum of Art, New York*

33 The Fireplace, *1923. Oil on canvas, 51⅛ × 29⅛″ (130 × 74 cm). Kunsthaus, Zurich*

34 Fruit on a Tablecloth with Fruit Dish, *1925. Oil on canvas, 51⅜ × 29½″ (130.5 × 75 cm). Musée National d'Art Moderne, Centre Georges Pompidou, Paris*

35 Still Life with Clarinet, *1927. Oil on canvas, 20⅞ × 29⅛″ (53 × 74 cm). The Phillips Collection, Washington, D.C.*

36 The Beach at Dieppe, *1929. Oil on canvas, 9½ × 13¾″ (24 × 35 cm). Moderna Museet, Stockholm*

37 The Large Pedestal Table, *1929. Oil on canvas, 57½ × 44¾″ (146 × 113.5 cm). The Phillips Collection, Washington, D.C.*

38 The Pink Tablecloth, *1933. Oil and sand on canvas, 38⅛ × 51⅛″ (97 × 130 cm). Chrysler Art Museum, Provincetown*

39 Reclining Nude on a Table, *1931. Oil on canvas, 9½ × 16⅛″ (24 × 41 cm). Private collection*

40 Still Life with Red Tablecloth, *1934. Oil on canvas, 31⅞ × 39¾″ (81 × 101 cm). Private collection, Paris*

41 Woman with a Mandolin, *1937. Oil on canvas, 51¼ × 38¼″ (130.2 × 97.2 cm). The Museum of Modern Art, New York*

42 The Table (Le Guéridon), *1938. Oil on canvas, 51¼ × 34¼″ (107 × 87 cm). Private collection*

43 The Painter and His Model, *1939. Oil on canvas, 51⅛ × 69¼″ (130 × 176 cm). Private collection*

44 Two Mullets, *1940–41. Oil on paper over canvas, 18½ × 24⅜″ (47 × 62 cm). Private collection*

45 Bottle and Two Fish, *1941. Oil on canvas, 13¼× 21⅞″ (33.5 × 55.5 cm). Musée National d'Art Moderne, Centre Georges Pompidou, Paris*

46 Still Life with a Skull, *1941–45. Oil on canvas, 19⅝ × 24″ (50 × 61 cm). Private collection*

47 Teapot and Grapes, *1942. Oil on canvas, 13 × 23⅞″ (33 × 60.5 cm). Galerie Adrien Maeght Collection, Paris*

48 The Mauve Garden Chair, *1947–60. Oil on canvas, 26 × 20⅛″ (66 × 51 cm). Private collection, New York*

49 Patience, *1942. Oil on canvas, 57⅛ × 44½″ (145 × 113 cm). Goulandris Collection, Lausanne*

50 Man with a Guitar, *1942–61. Oil on canvas, 51⅛ × 38⅛″ (130 × 97 cm). Private collection, Paris*

51 Man at an Easel, *1942. Oil on paper over canvas, 39⅜ × 31⅞″ (100 × 81 cm). Quentin Laurens Collection, Paris*

52 My Bicycle, *1941–60. Oil on paper over canvas, 36¼ × 28¾″ (92 × 73 cm). Private collection*

53 The Billiard Table, *1945. Oil on canvas, 35¼ × 45⅝″ (89.5 × 116 cm). Private collection, Paris*

54 The Salon, *1944. Oil on canvas, 47½ × 59¼″ (120.5 × 150.5 cm). Musée National d'Art Moderne, Centre Georges Pompidou, Paris*

55 The Vase of Lilacs, *1946. Oil on canvas, 31⅞ × 21¼″ (81 × 54 cm). Private collection, Paris*

56 Still Life with a Lobster, *1948–50. Oil on canvas, 63¾ × 28¾″ (162 × 73 cm). Galerie Adrien Maeght Collection, Paris*

57 Studio II, *1949. Oil on canvas, 51⅝ × 64″ (131 × 162.5 cm). Kunstsammlung Nordrhein-Westfalen, Düsseldorf*

58 Studio IX, *1952–56. Oil on canvas, 57½ × 57½″ (146 × 146 cm). Musée National d'Art Moderne, Centre Georges Pompidou, Paris*

59 Studio III, *1949–51. Oil on canvas, 57⅛ × 68⅞″ (145 × 175 cm). Private collection, Vaduz*

60 The Night, *1951. Oil on canvas, 64 × 28¾″ (162.5 × 73 cm). Galerie Adrien Maeght Collection, Paris*

61 Bird in Squares, *1952–53. Oil on canvas, 52⅜ × 29⅞″ (133 × 76 cm). Private collection, Paris*

62 Black Birds, *1956–57. Oil on canvas, 50¾ × 71¼″ (129 × 181 cm). Galerie Adrien Maeght Collection, Paris*

63 Sketch for a ceiling at the Louvre, *1953. Oil on paper, 45¼ × 35⅜″ (115 × 90 cm). Galerie Adrien Maeght Collection, Paris*

64 The Field of Colza, *1956–57. Oil on canvas, 7⅞ × 25⅝″ (20 × 65 cm). Private collection, Paris*

65 Landscape, *1959. Oil on canvas, 8¼ × 28¾″ (21 × 73 cm). Galerie Adrien Maeght Collection, Paris*

66 Landscape with Plough, *1955. Oil on canvas, 13⅜ × 25¼″ (34 × 64 cm). Galerie Adrien Maeght Collection, Paris*

67 A Nest in the Foliage, *1958. Oil on canvas, 44⅞ × 52″ (114 × 132 cm). Galerie Adrien Maeght Collection, Paris*

68 The Metal Plough, *1962. Oil on canvas, 13 × 15¾″ (33 × 40 cm). Private collection*

69 Birds in Flight, *1960. Oil on canvas, 52¾ × 66″ (134 × 167.5 cm). Private collection, Paris*

70 Bird in the Foliage, *1961. Lithograph, 31¾ × 41⅜″ (80.5 × 105 cm). Galerie Adrien Maeght Collection, Paris*

Selected Bibliography

Georges Braque, catalogue of the exhibition, Orangerie des Tuileries. Paris: Éditions de la Réunion des musées nationaux, 1973–74.

Georges Braque, rétrospective, juillet–octobre 1994, St. Paul-de-Vence: Fondation Maeght

Faucherau, Bernard. *Braque.* Barcelona: Ediciones Polígrafa, 1987.

Mangin S., Nicole. *Catalogue de l'œuvre de Georges Braque: 1907–1957,* 6 vols. Paris: Éditions Maeght, 1959–82.

Pouillon, N., and Monod-Fontaine, I. *Œuvres de Georges Braque, Collections du Musée National d'Art Moderne.* Paris: Éditions du Centre Georges Pompidou, 1982.

Rubin, William. *Picasso y Braque, la invención del cubismo.* Barcelona: Ediciones Polígrafa, 1991.

Zurcher, Bernard. *Braque, vie et œuvre.* Nathan, 1988.

Series coordinator, English-language edition: Ellen Rosefsky Cohen
Editor, English-language edition: Amy L. Vinchesi
Designer, English-language edition: Judith Michael

Library of Congress Catalog Card Number: 96–86851
ISBN 0–8109–4695–5

Copyright © 1995 Ediciones Polígrafa, S.A. and Globus Comunicación, S.A.
Reproductions copyright © 1995 Georges Braque. VEGAP, Barcelona
English translation copyright © 1997 Harry N. Abrams, Inc.

Published in 1997 by Harry N. Abrams, Incorporated, New York
A Times Mirror Company
Printed and bound in Spain by La Polígrafa, S.L.
Parets del Vallès (Barcelona)
Dep. Leg.: 35.281 - 1996